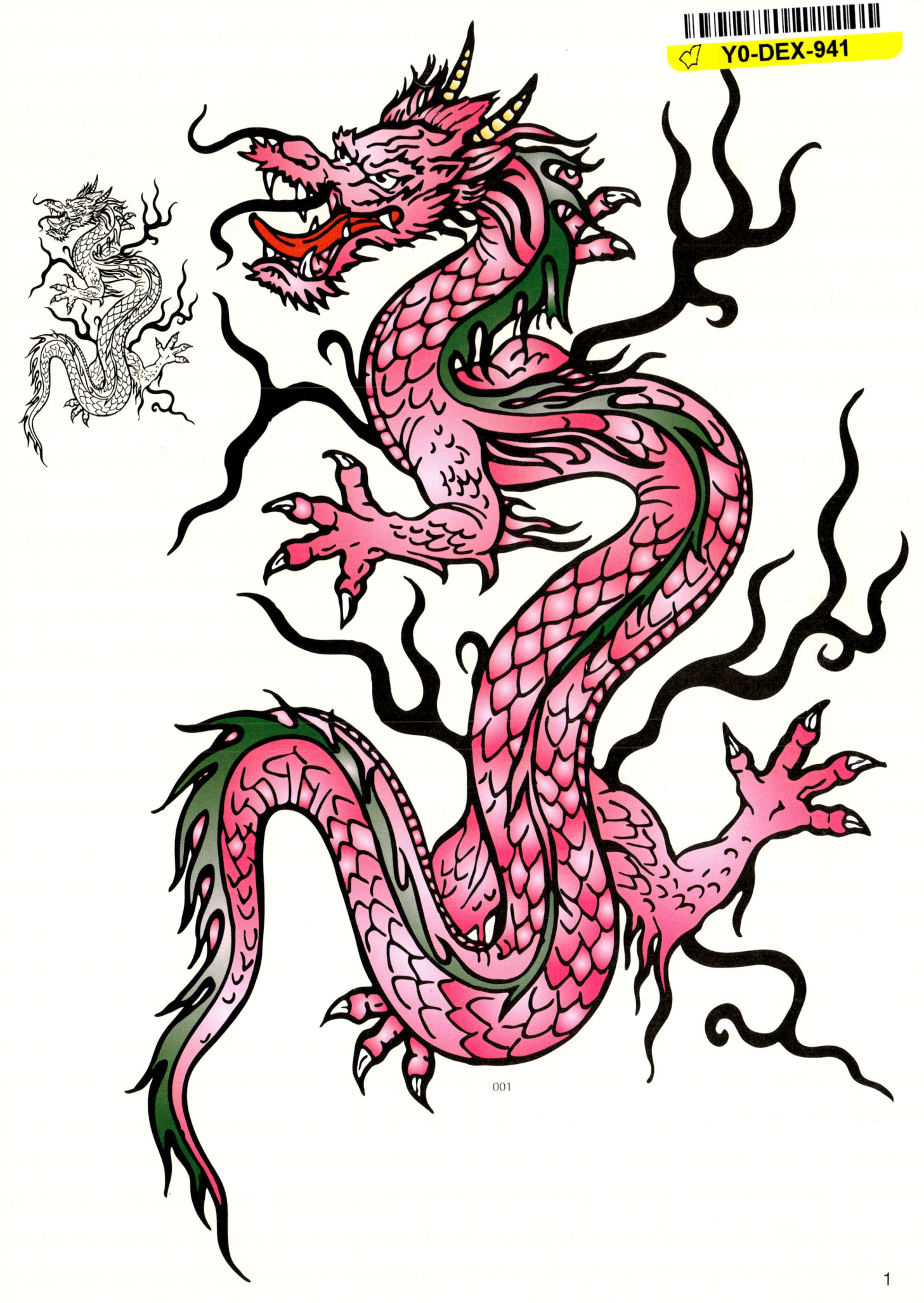

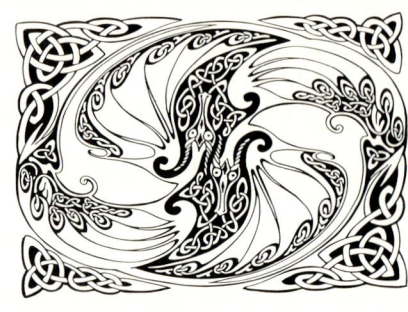

What's on the cd?

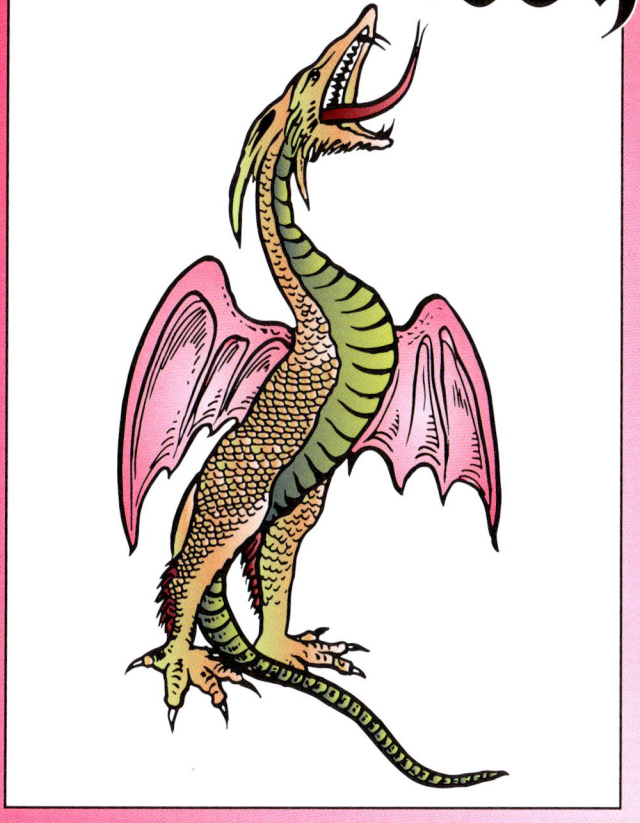

color renderings—high resolution JPG

Each color image printed in this book is included on the CD in a variety of formats useful to the tattoo artist and enthusiast.

The color rendering is great for visualizing a final result; the color can be manipulated and adjusted in most image-editing programs.

The black & white outline can be resized and printed for use in transferring the image to the recipient.

The black & white drawing can be resized, printed and used to transfer the image to the tattoo recipient. It can also be used as a template for creating hand-colored samples. This version is available for all illustrations within the book.

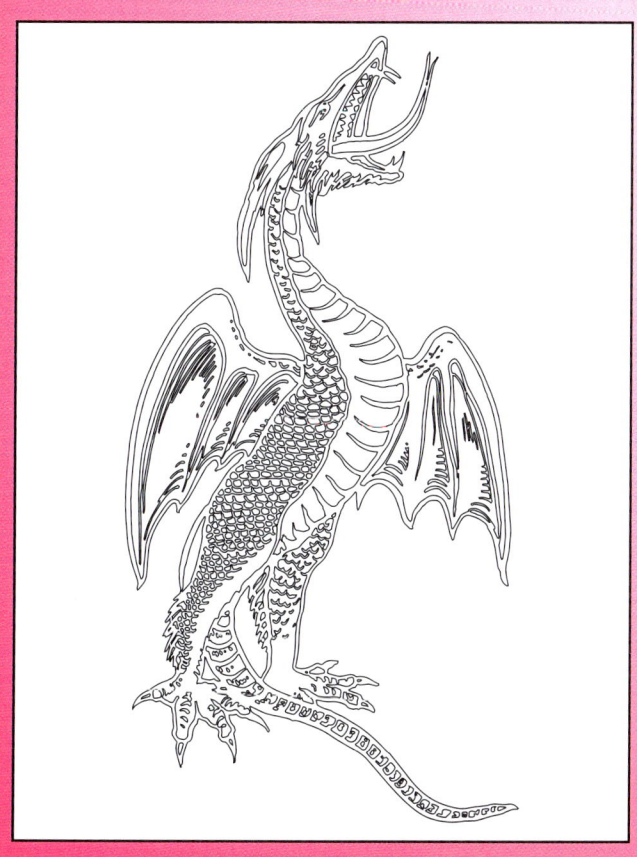

black & white outline—2 versions, scalable EPS vector, high-resolution JPG

black & white drawing—2 versions, scalable EPS vector, high-resolution JPG

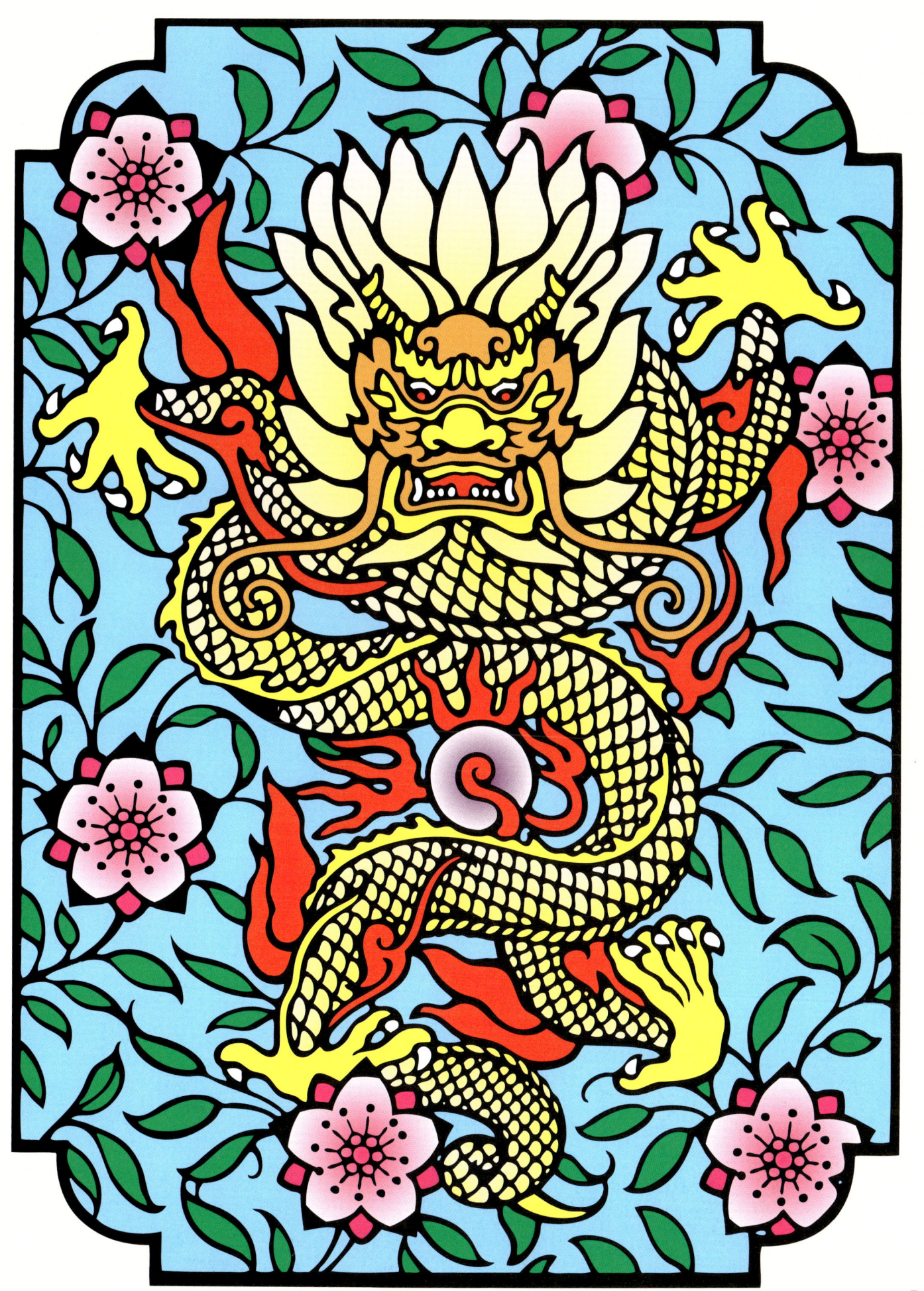

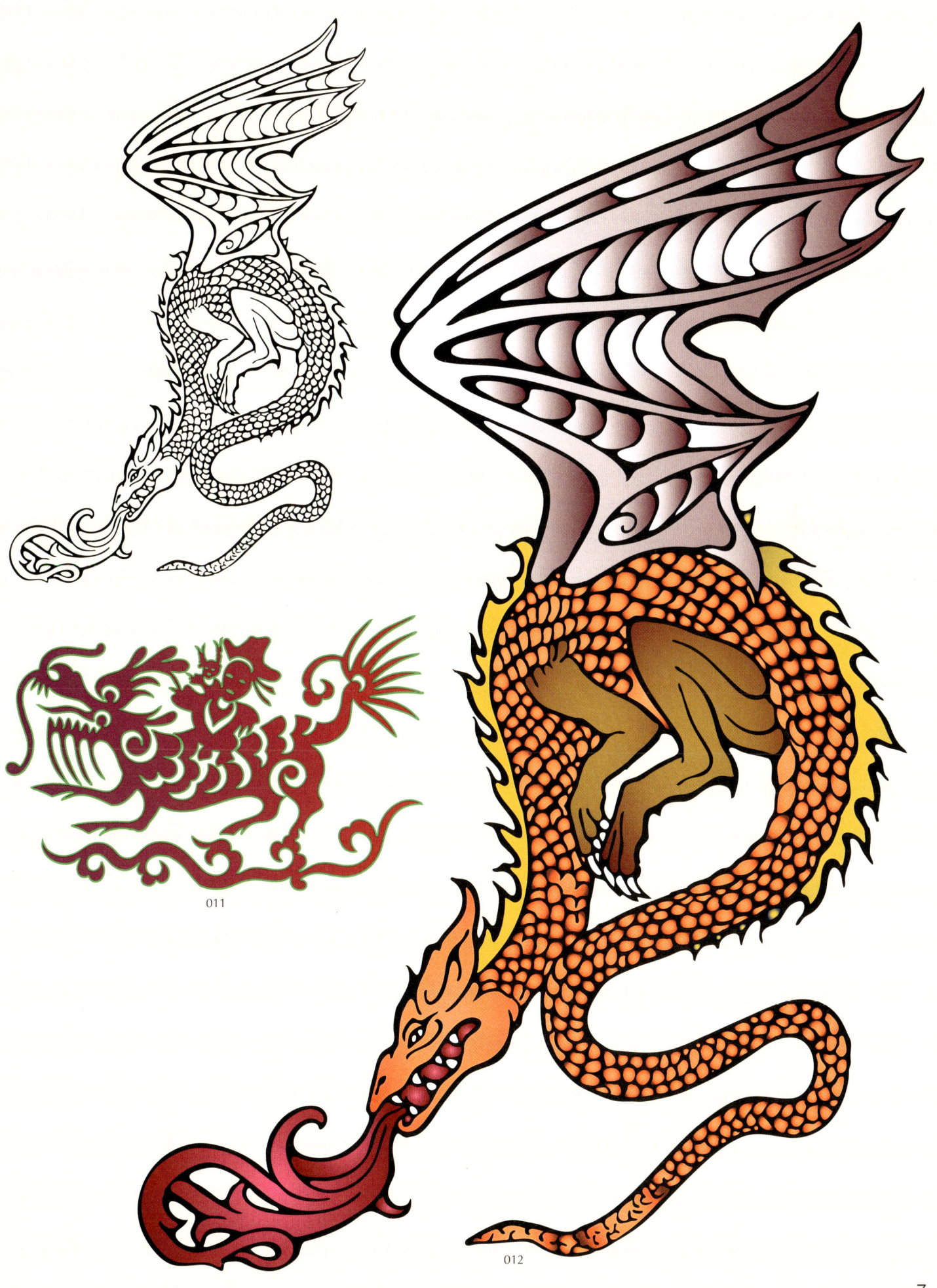

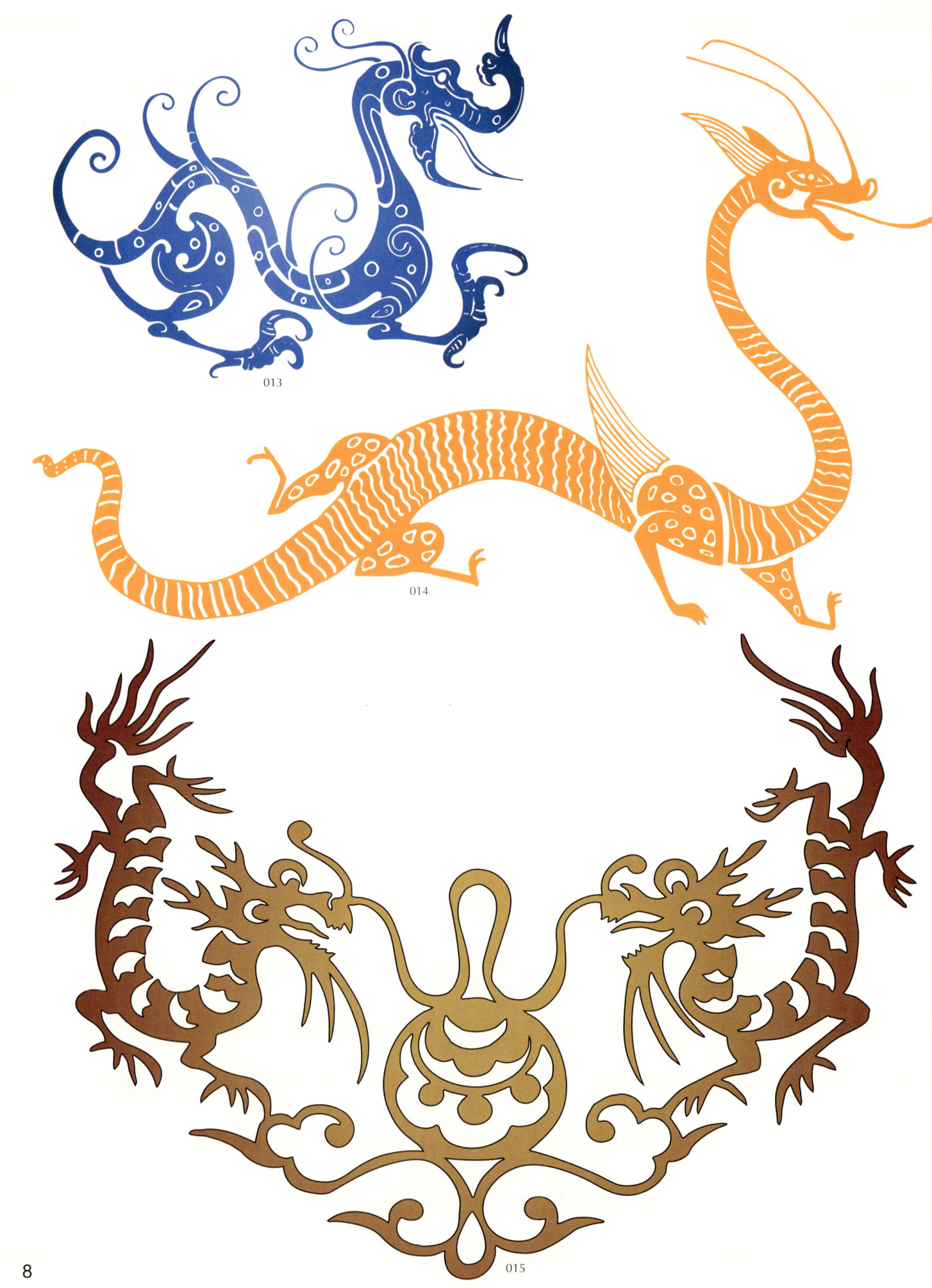

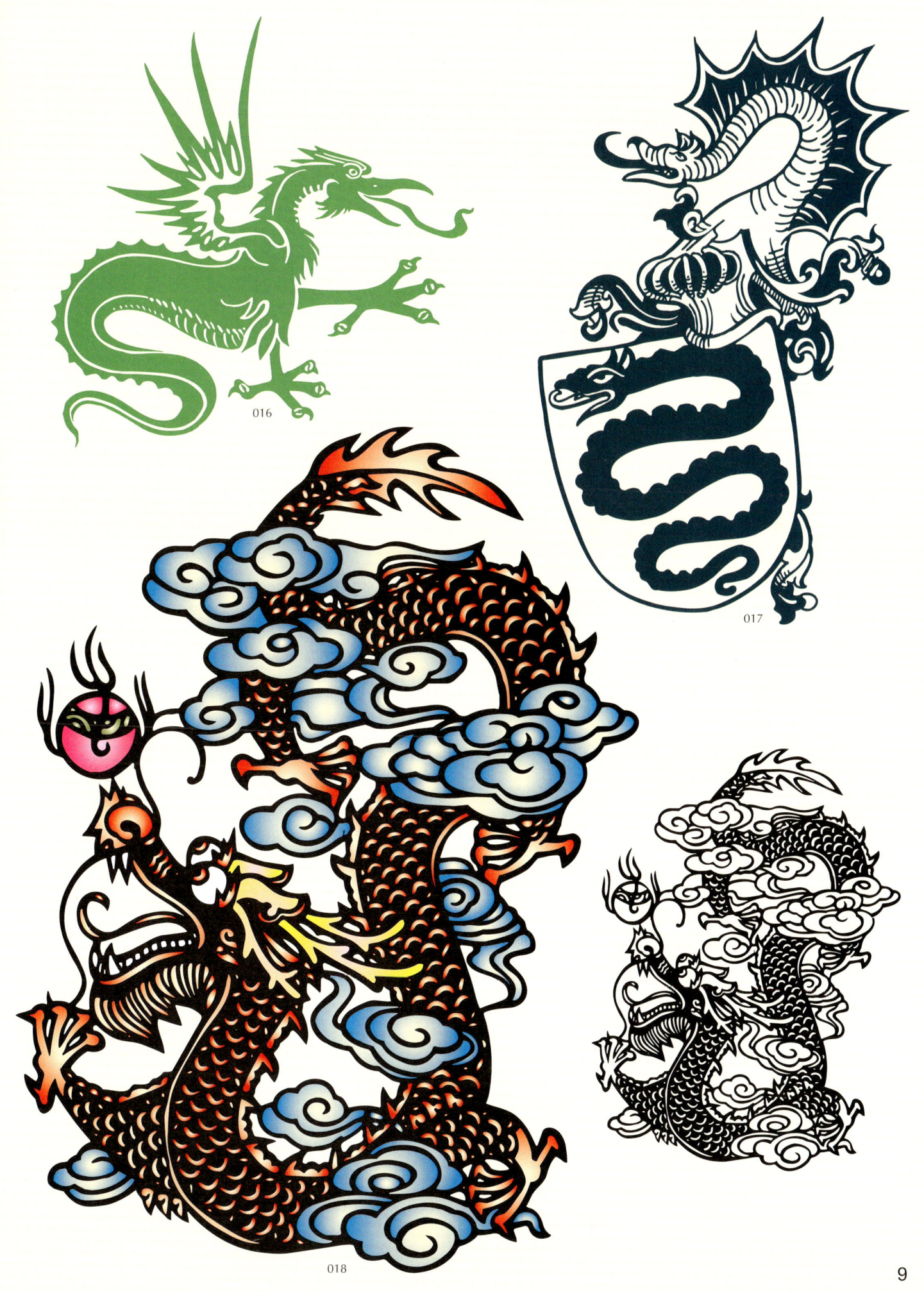

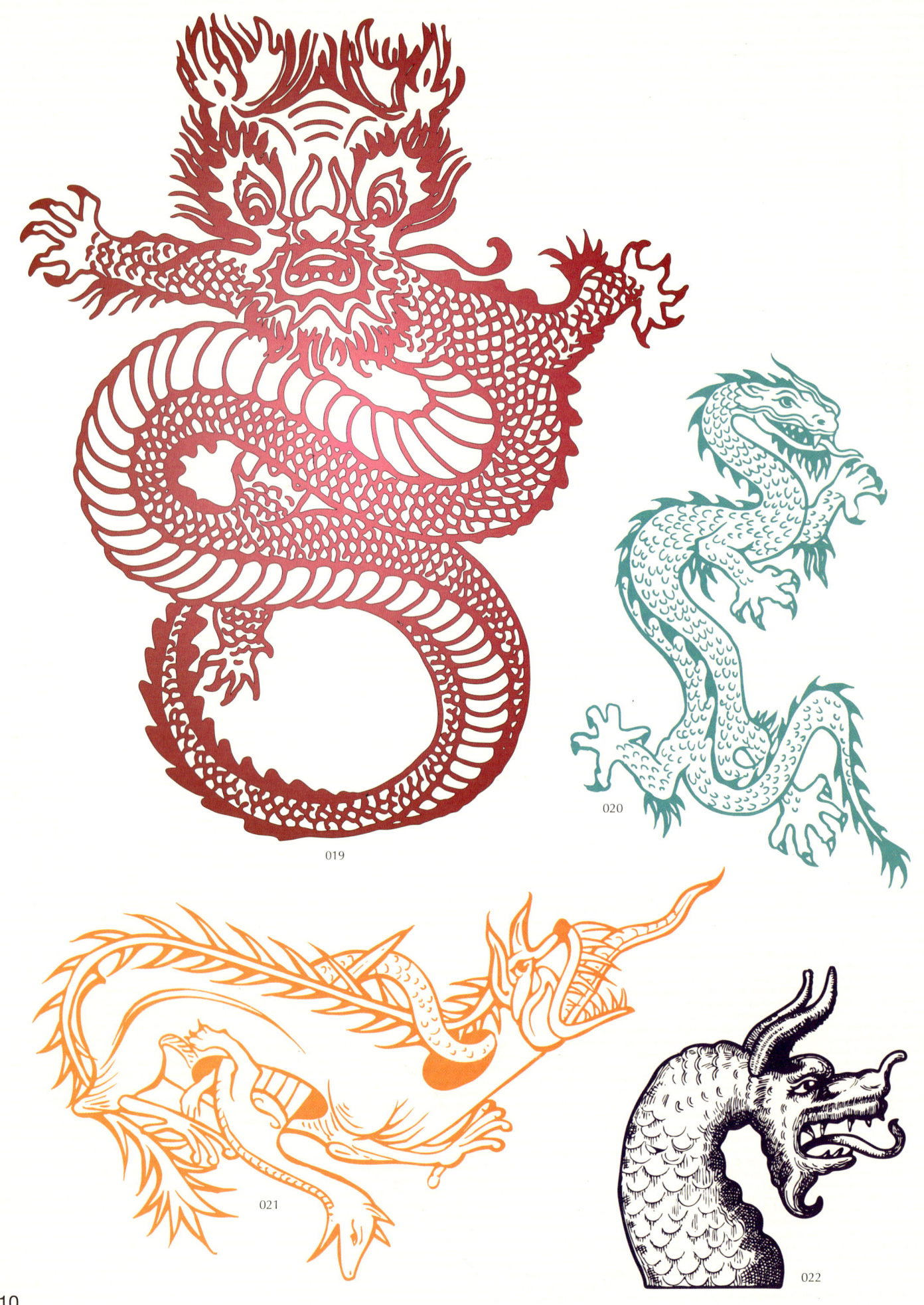

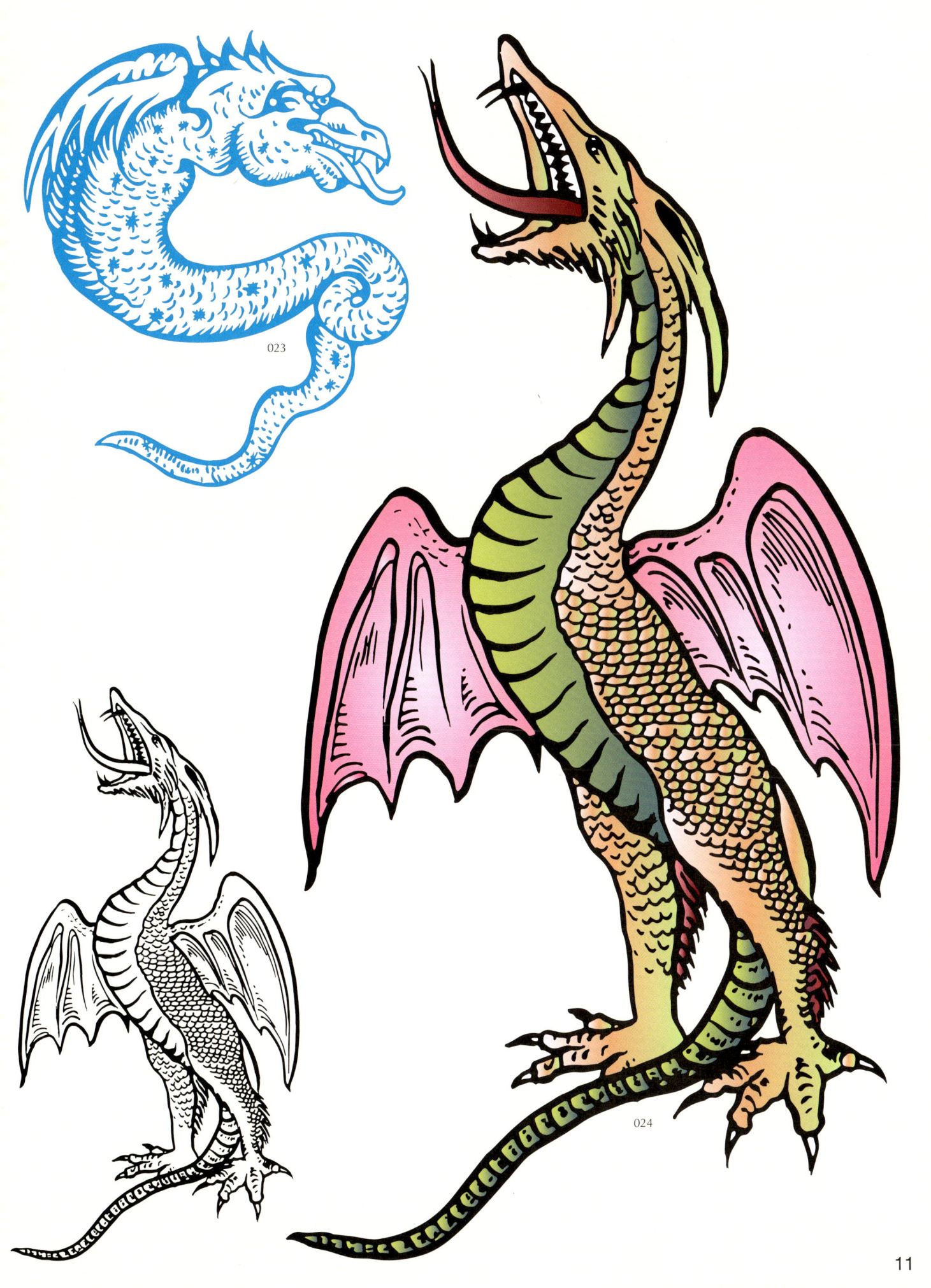

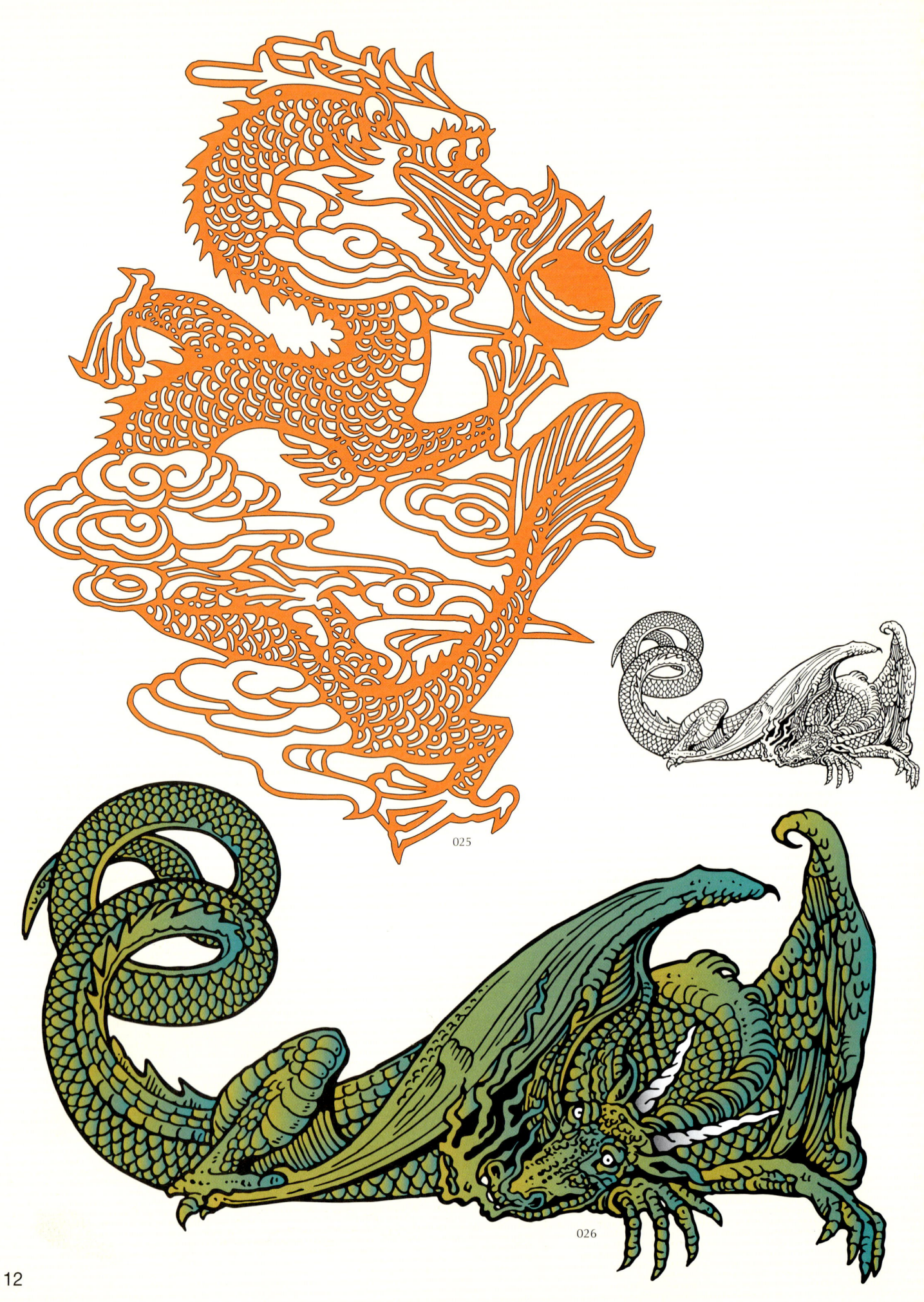

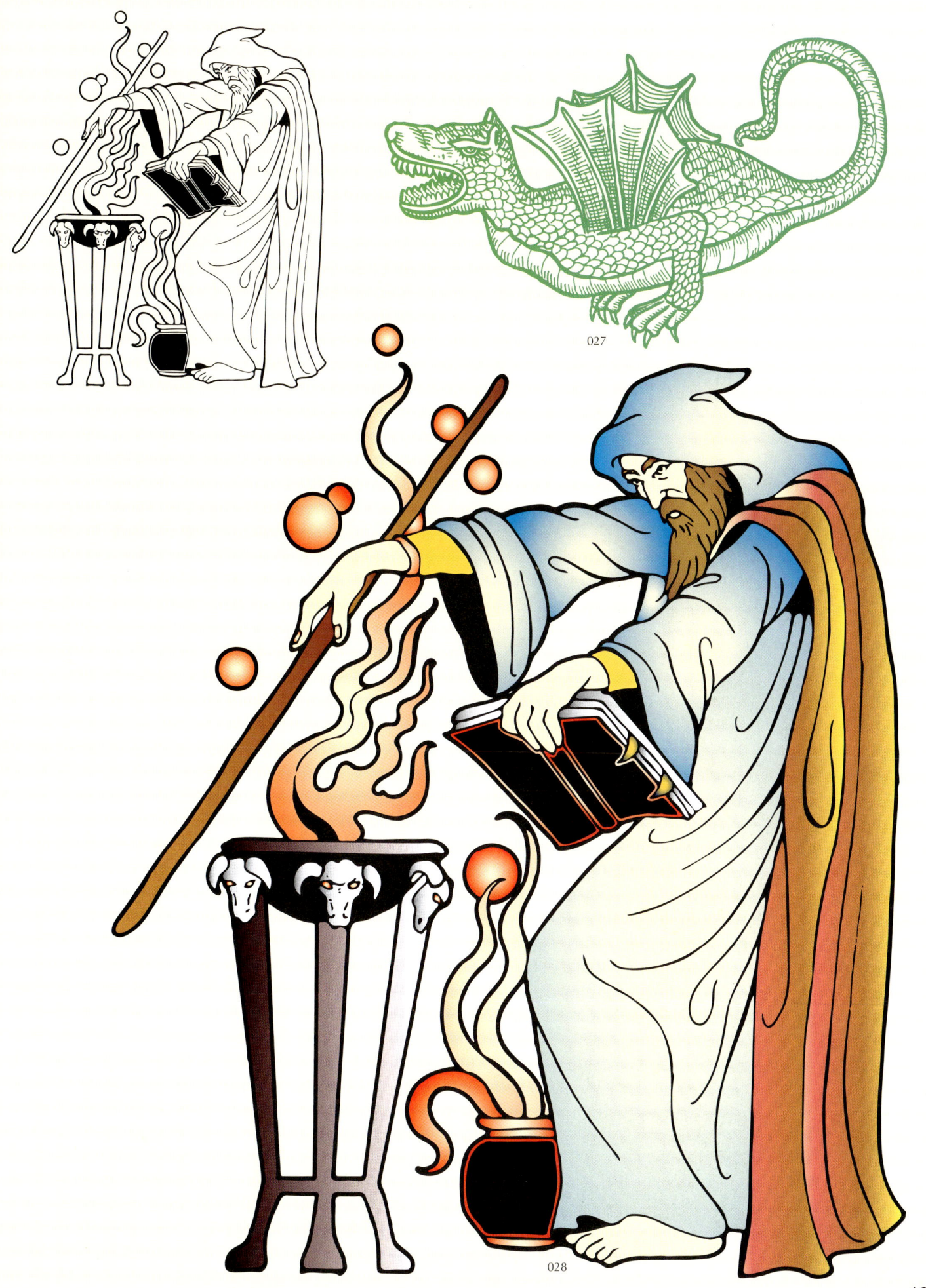

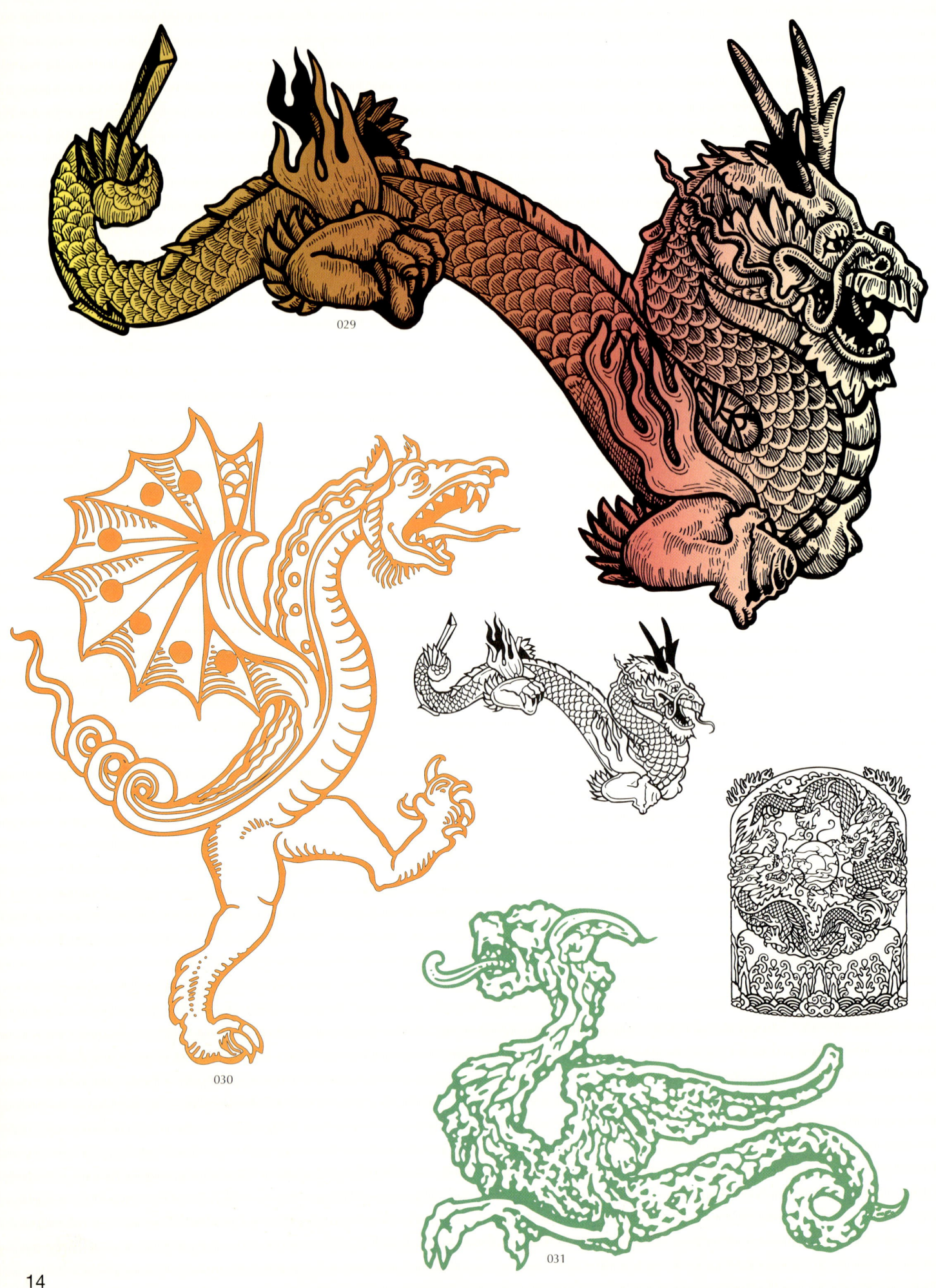

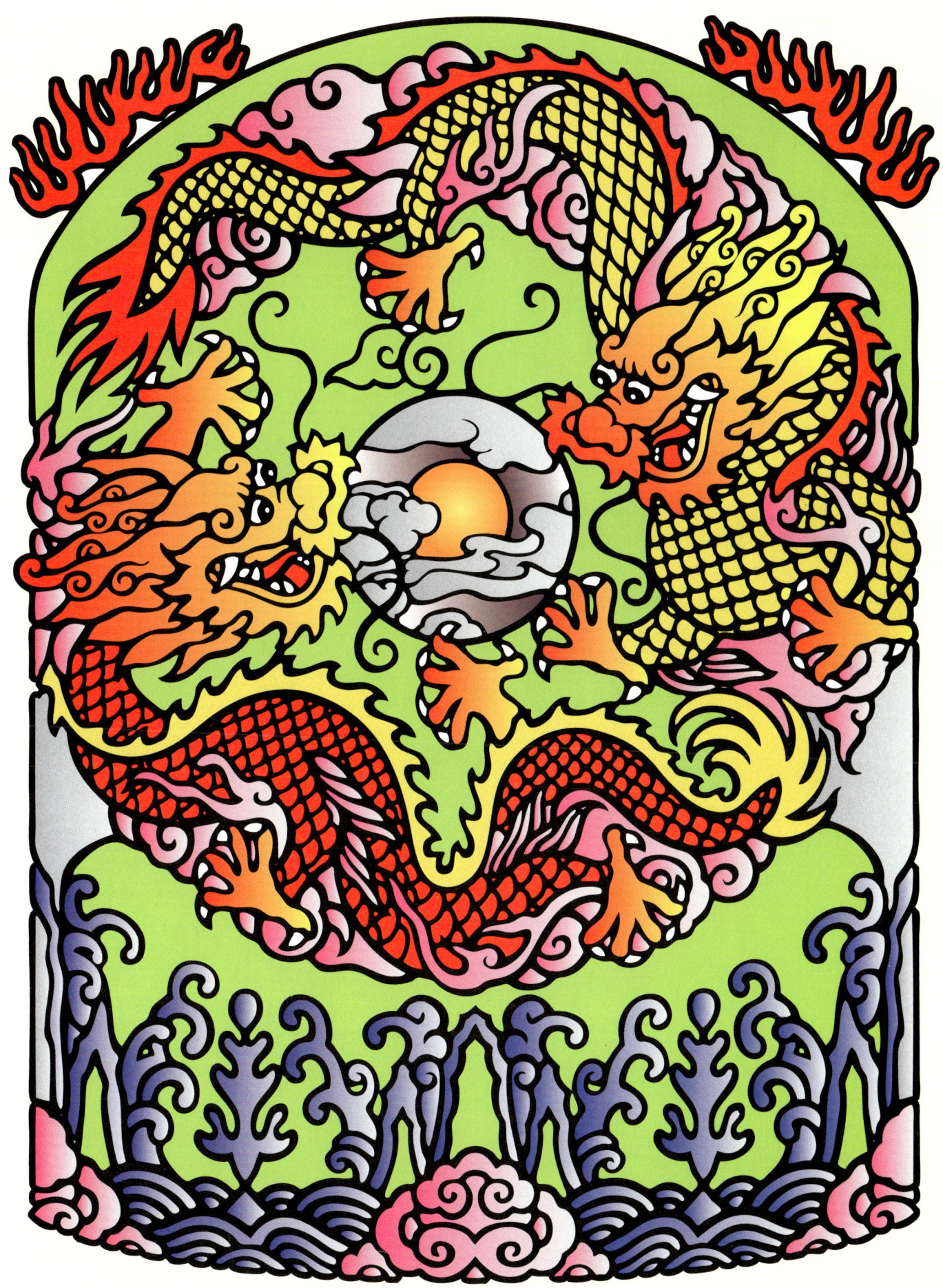

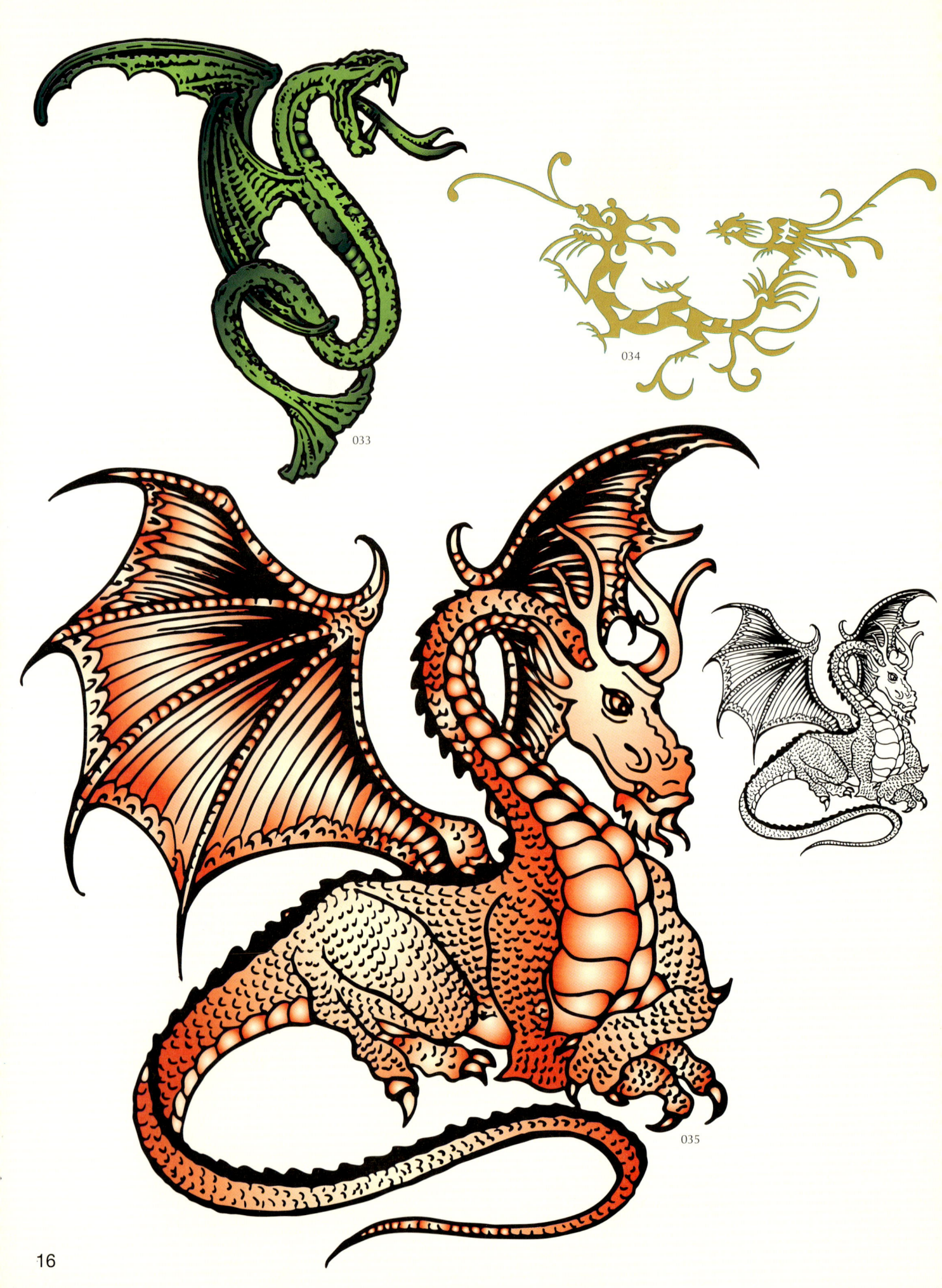

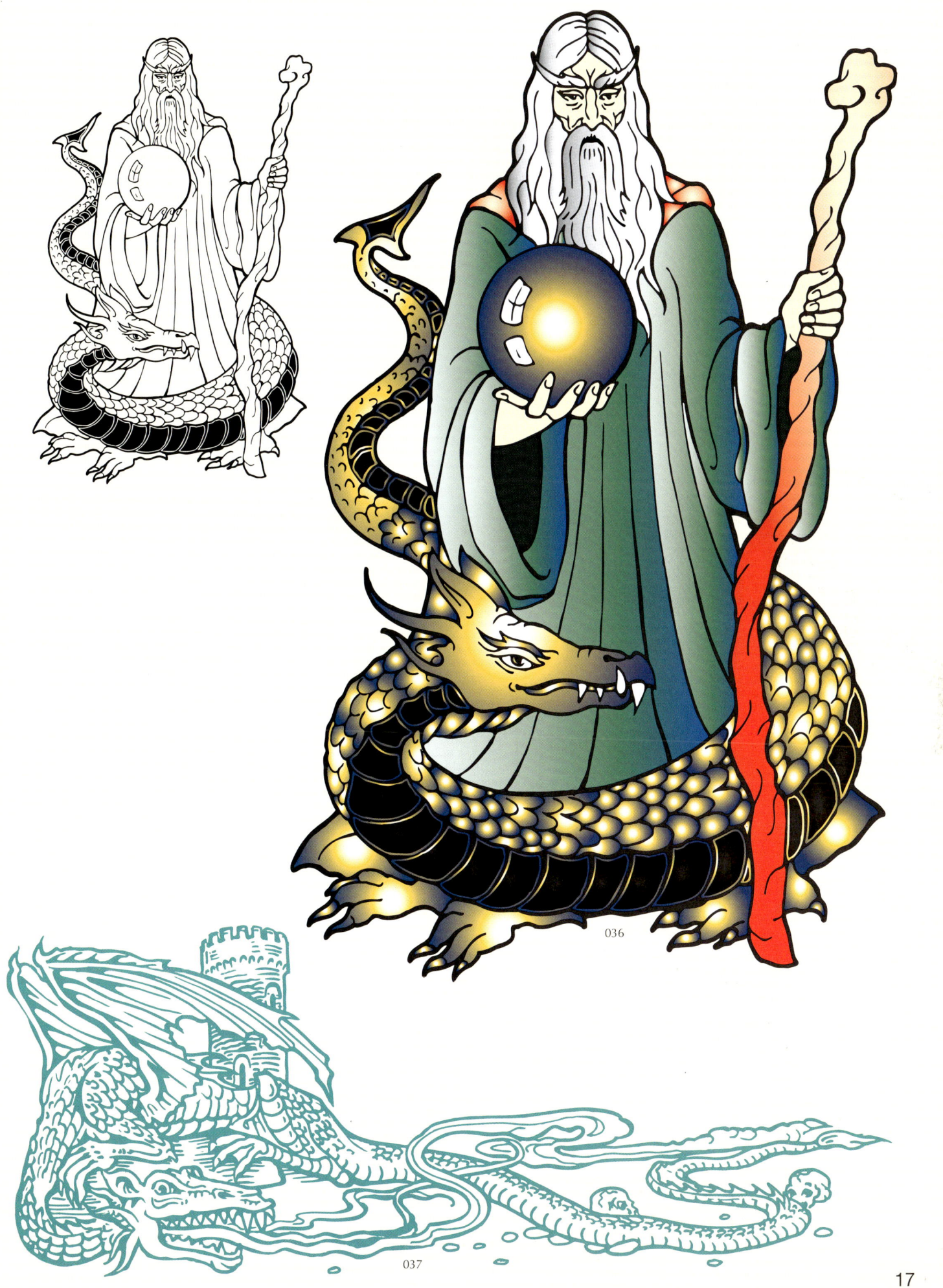

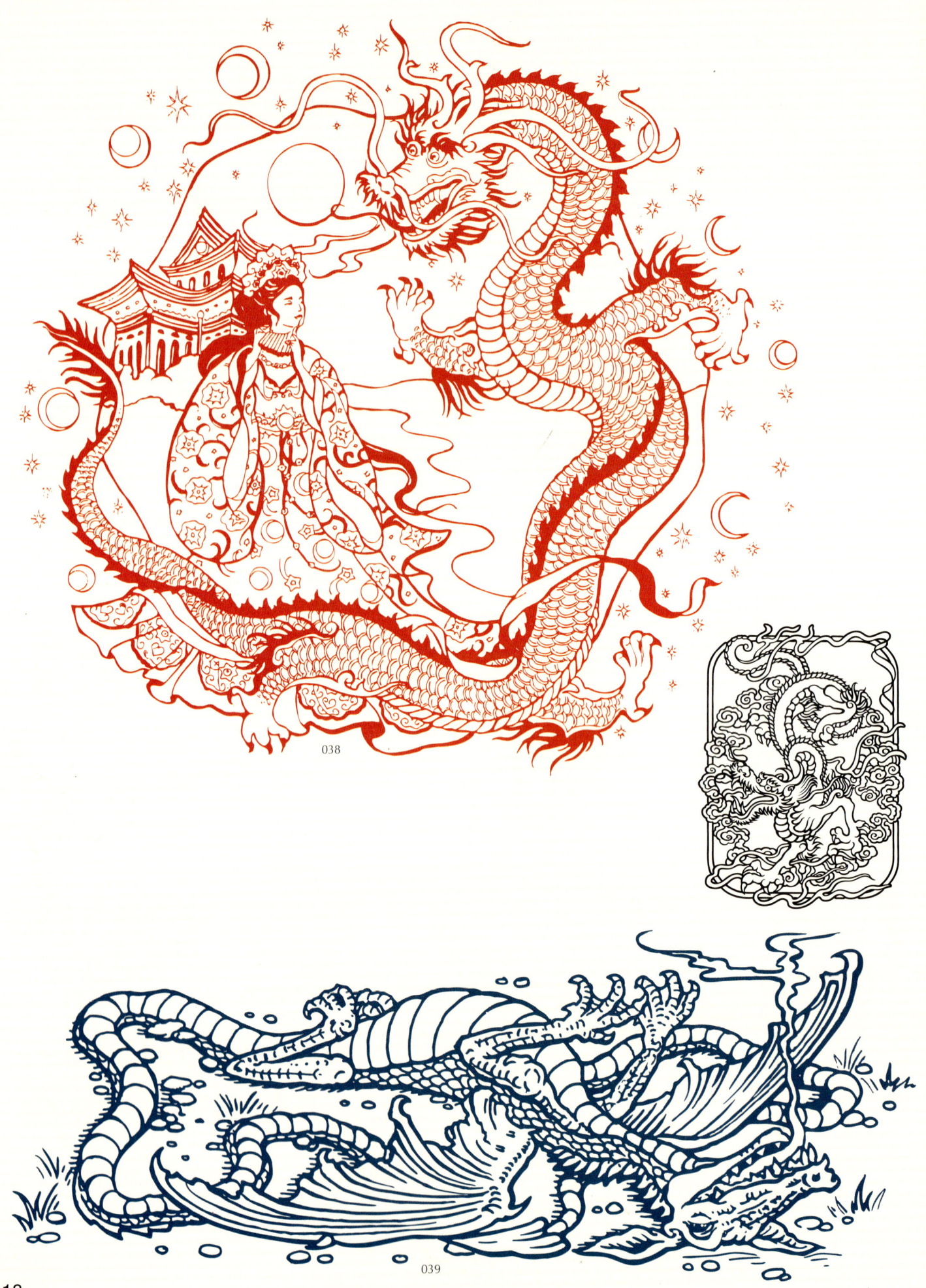

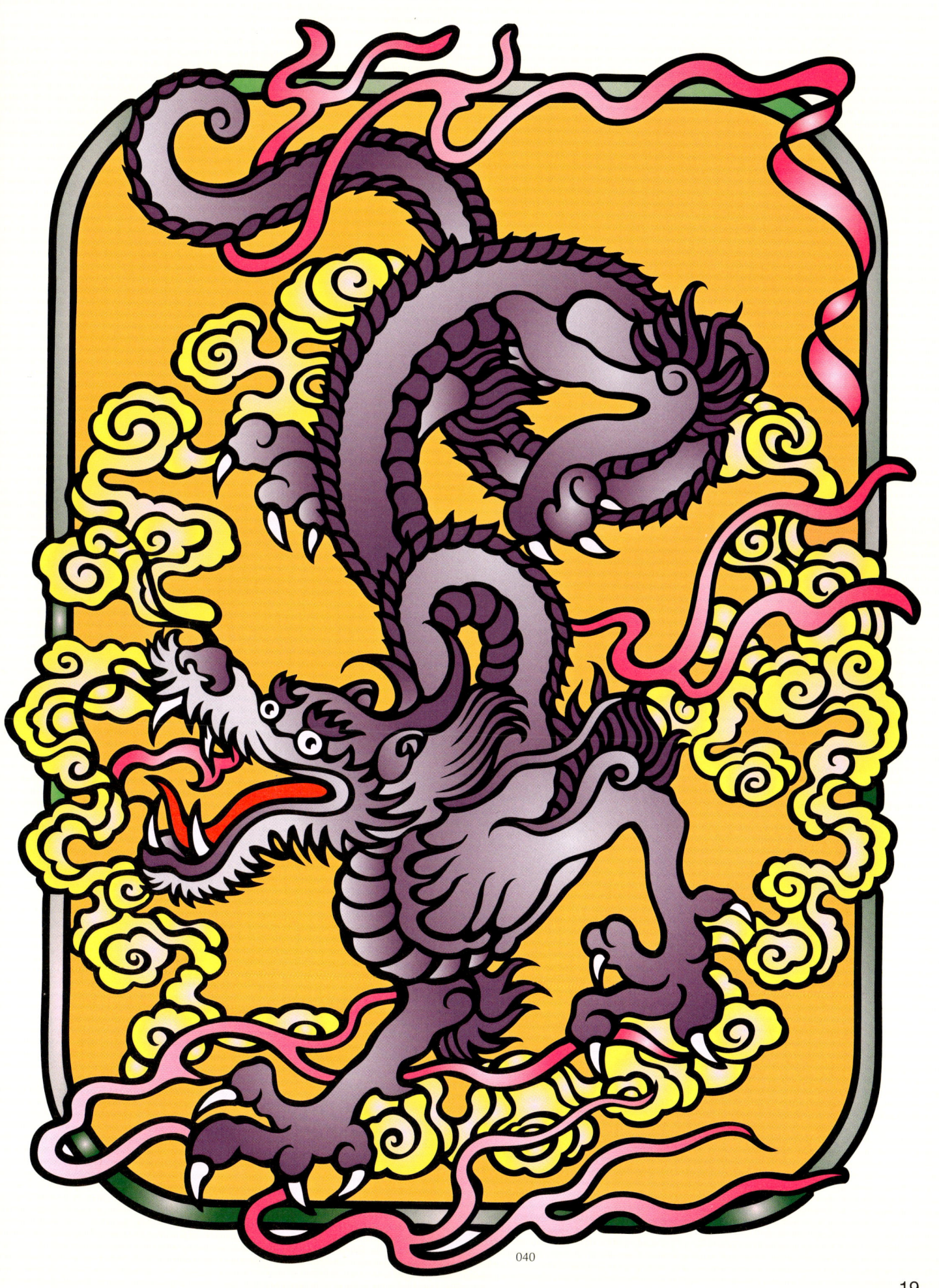

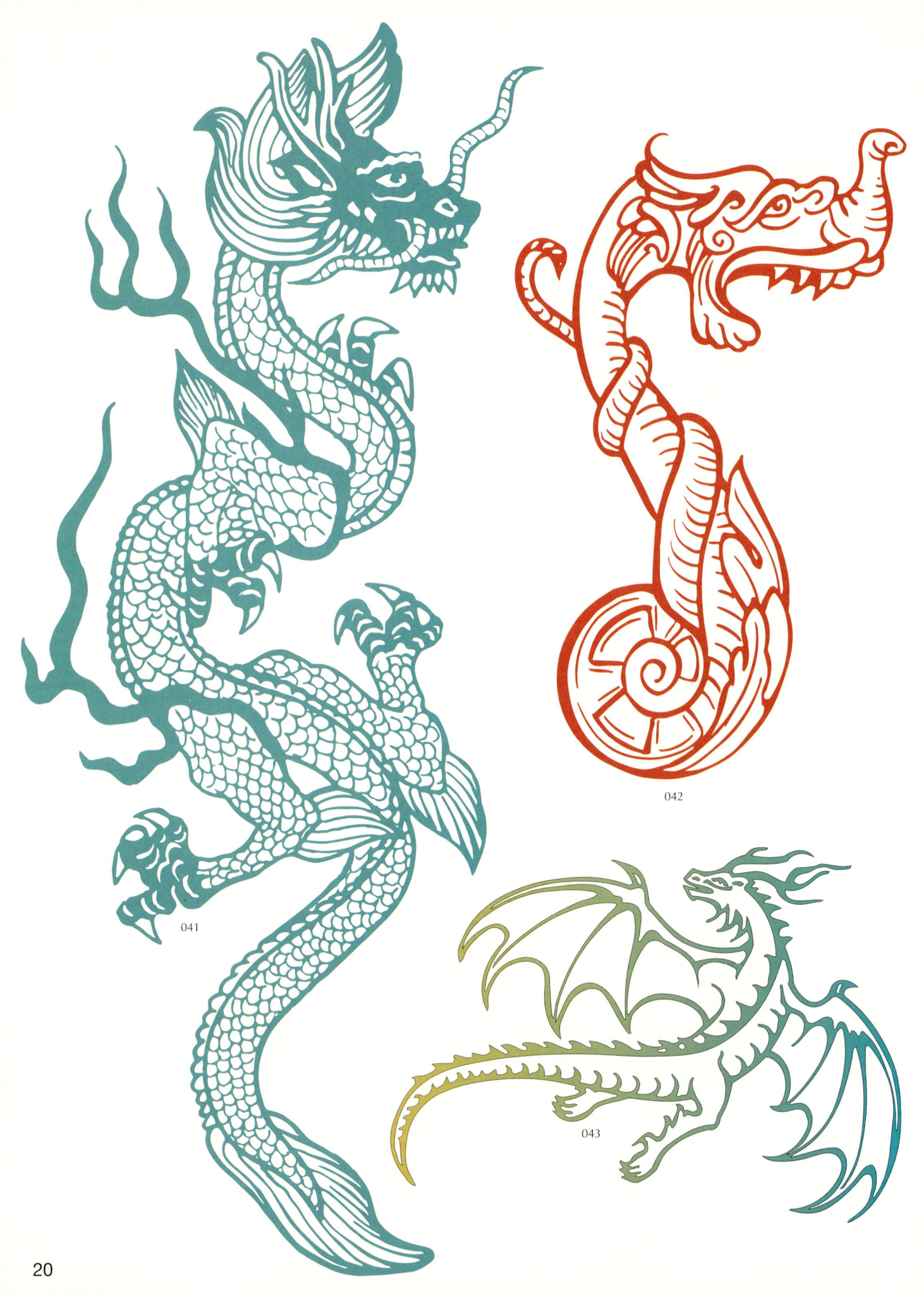

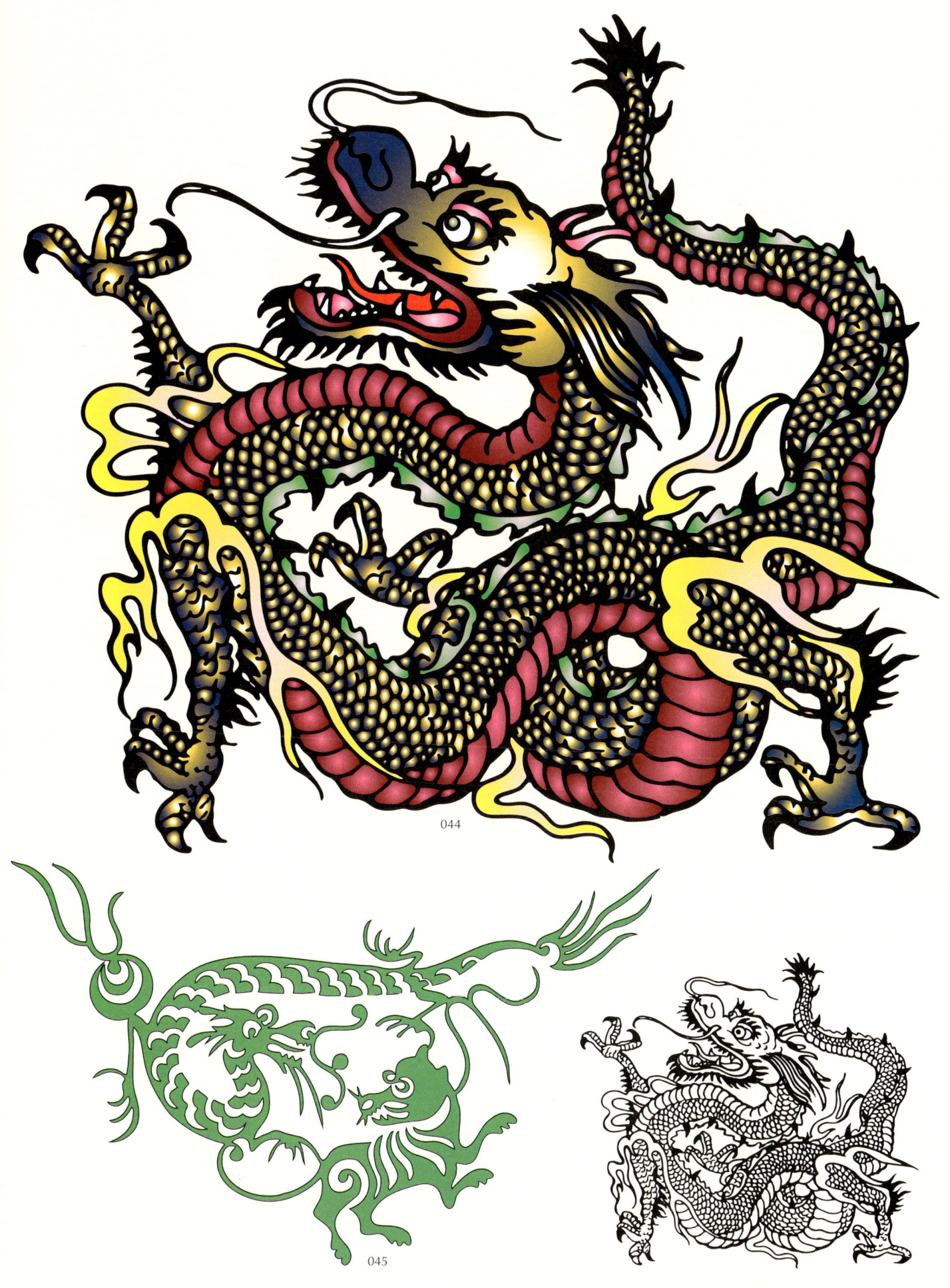

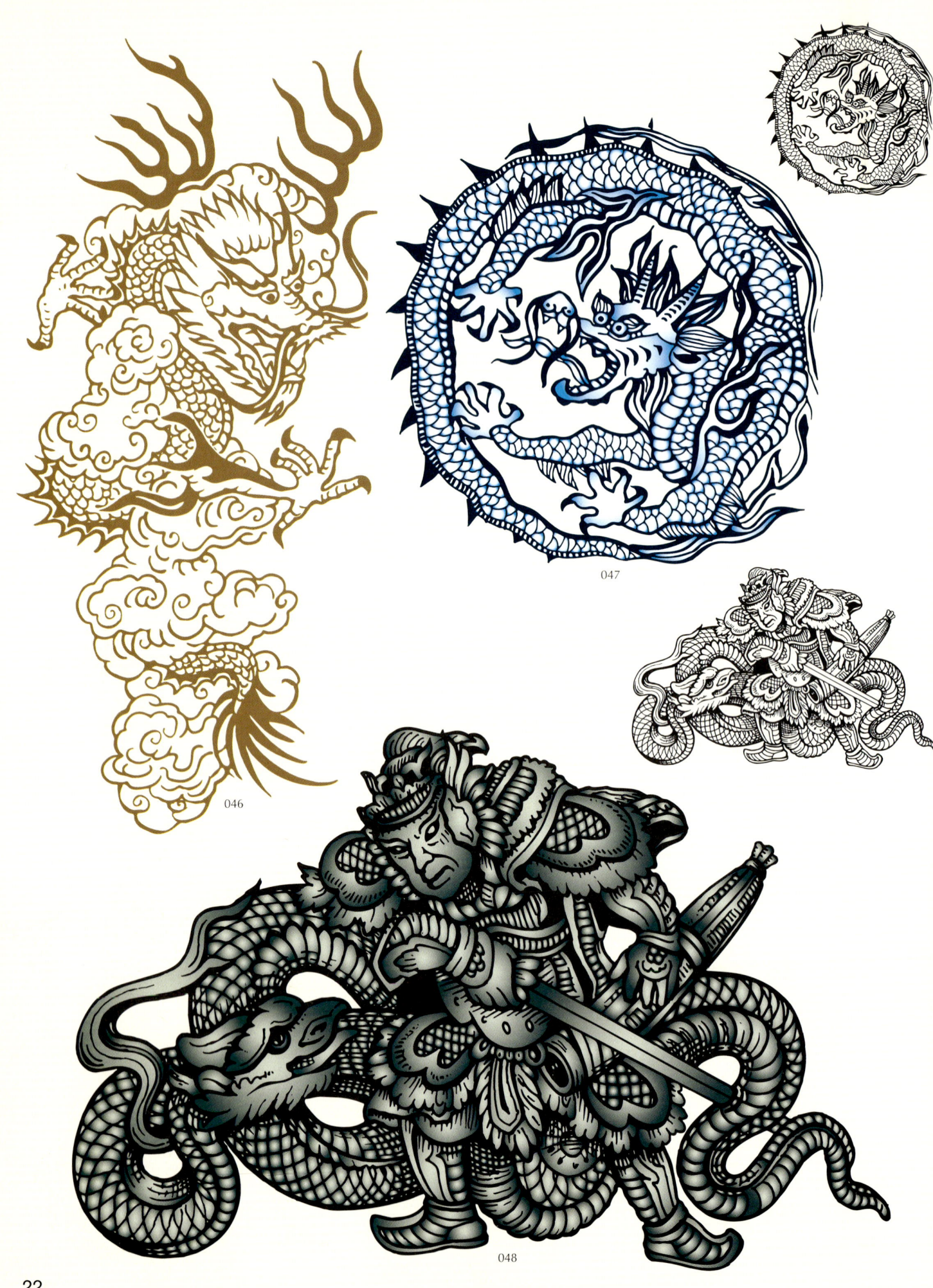

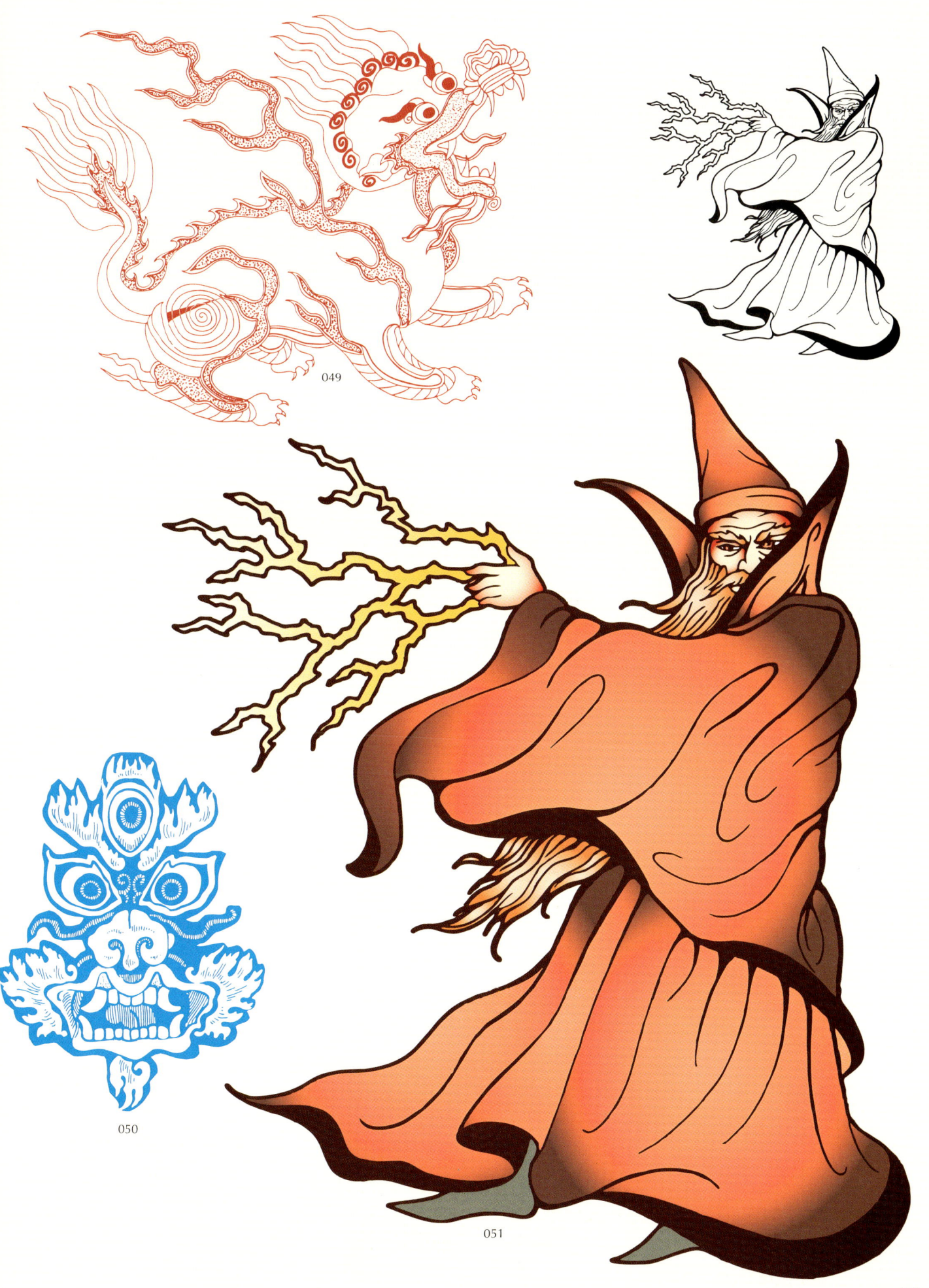

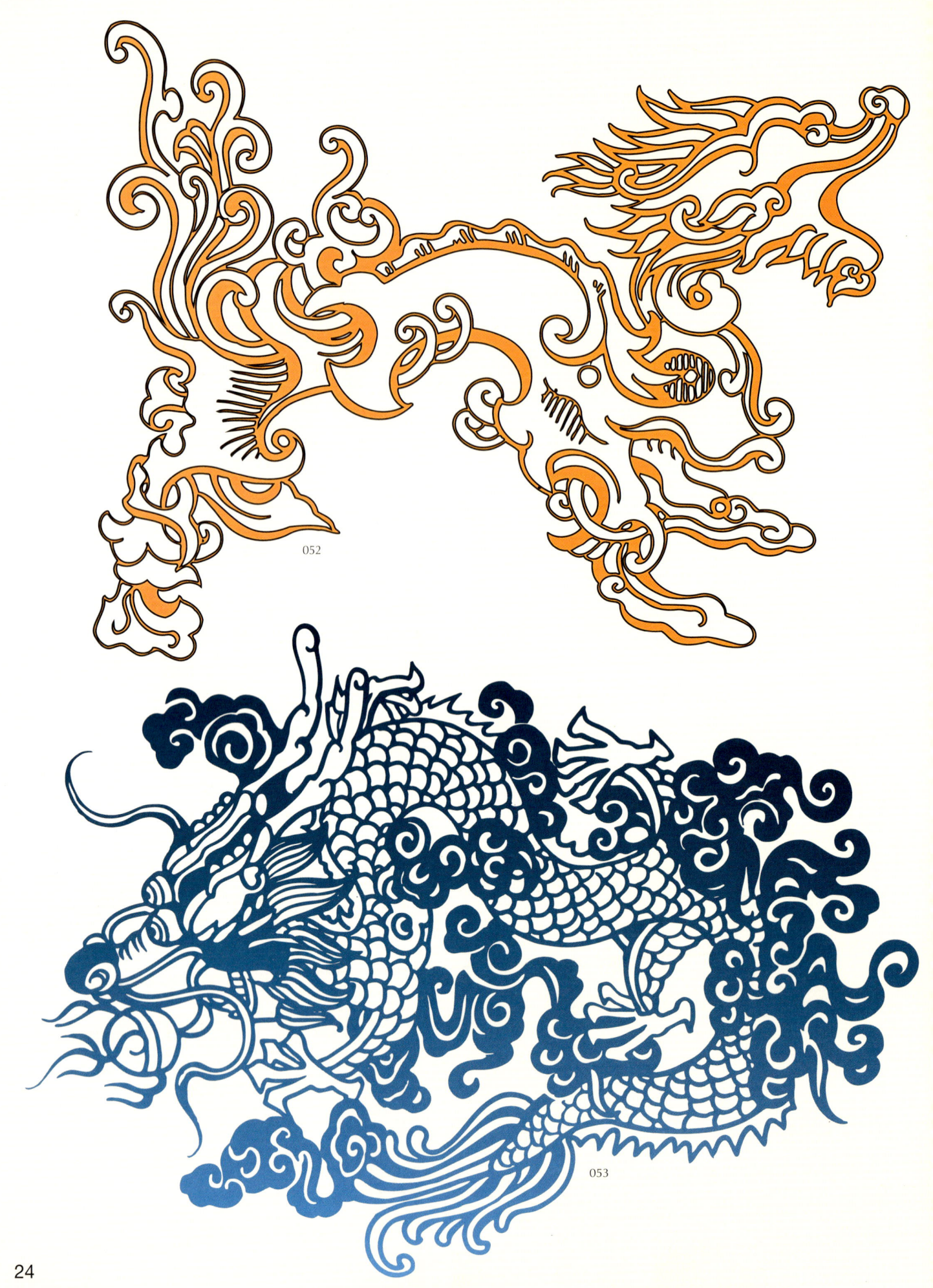

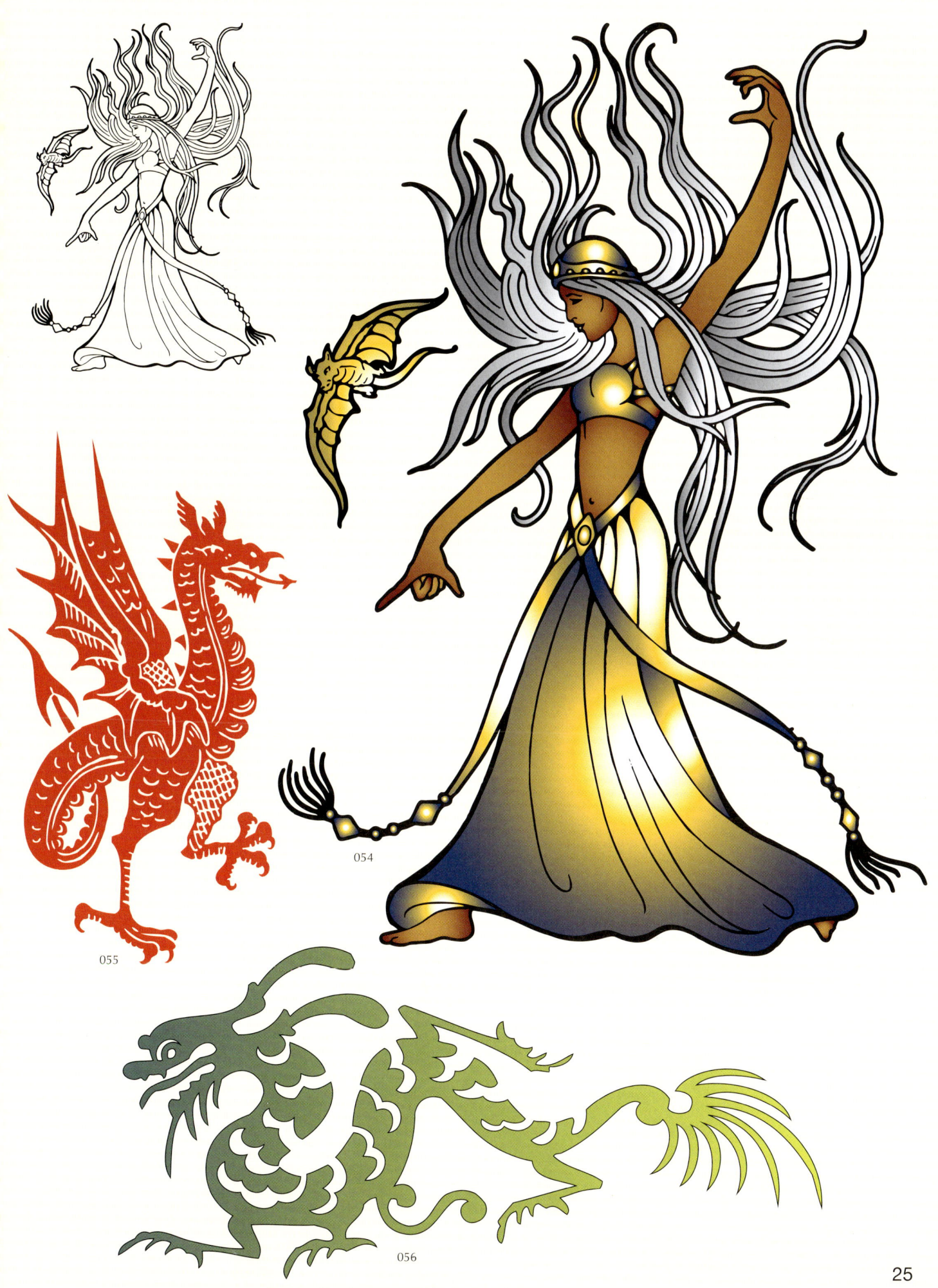

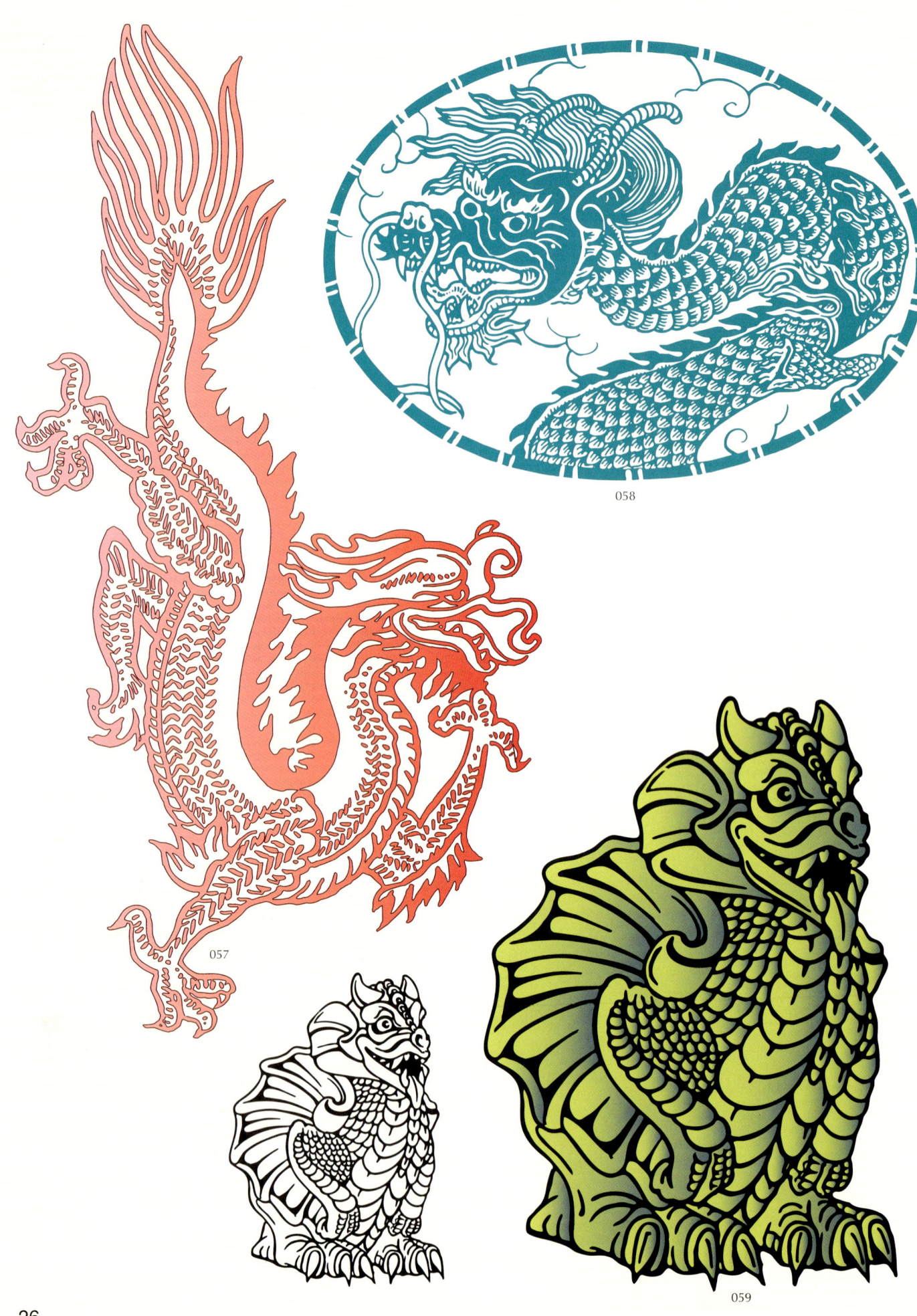

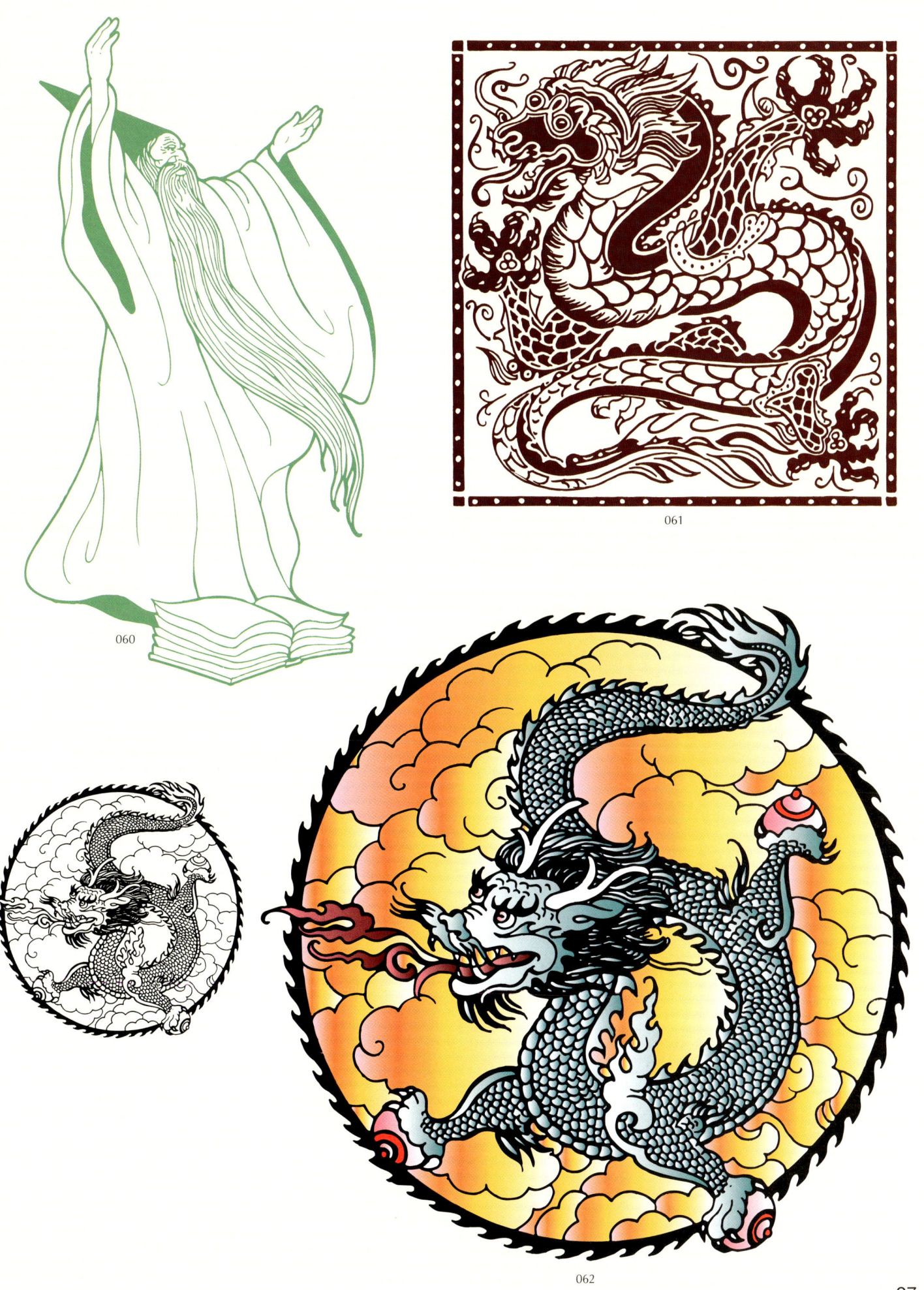

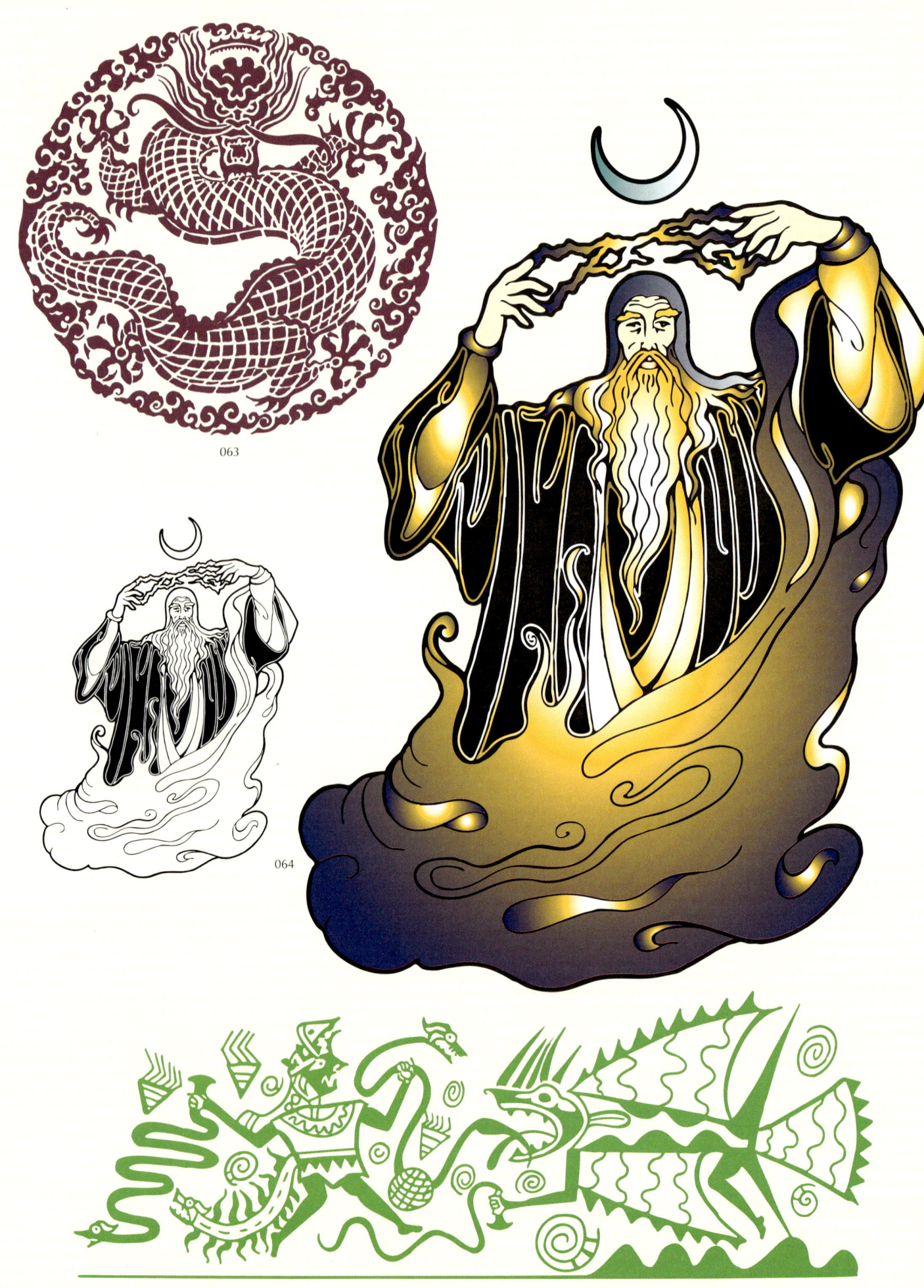

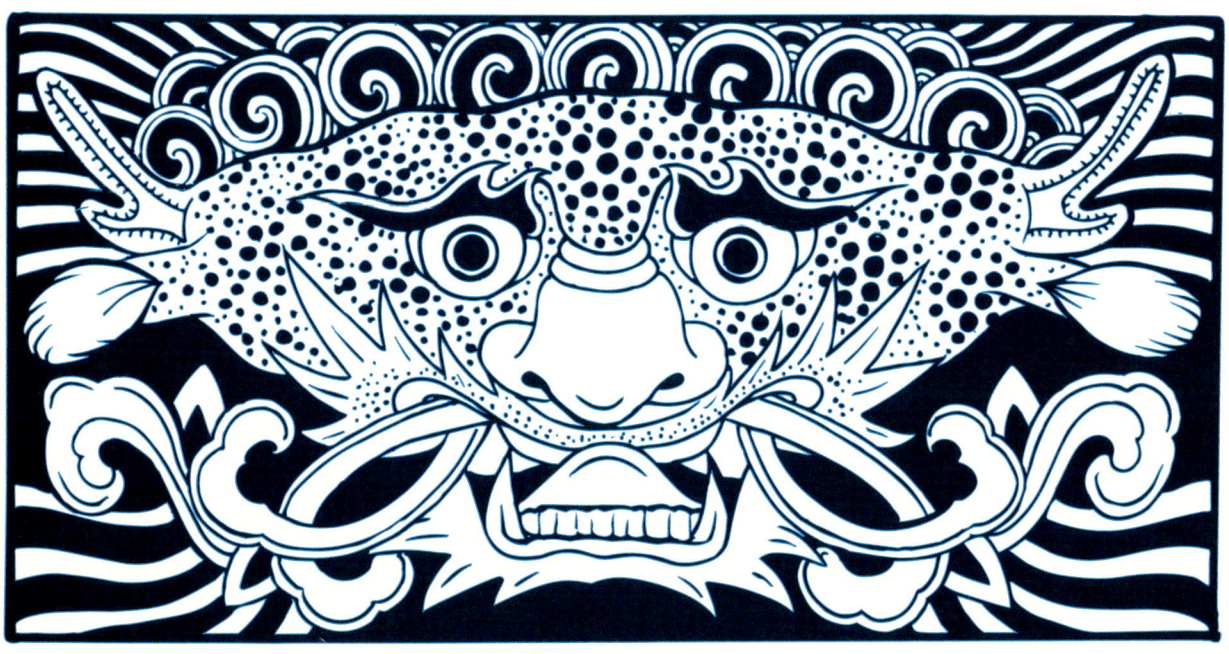

29

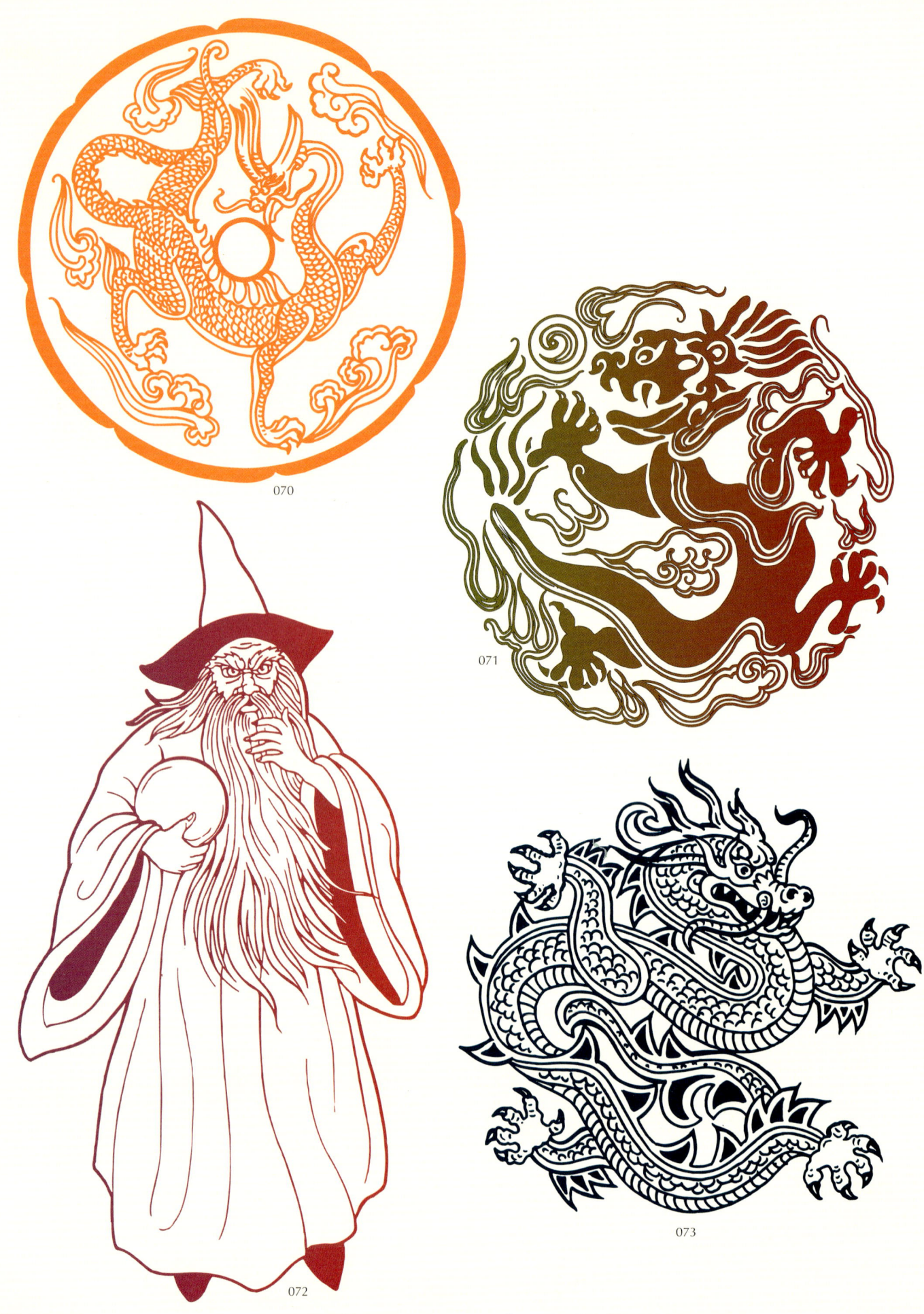

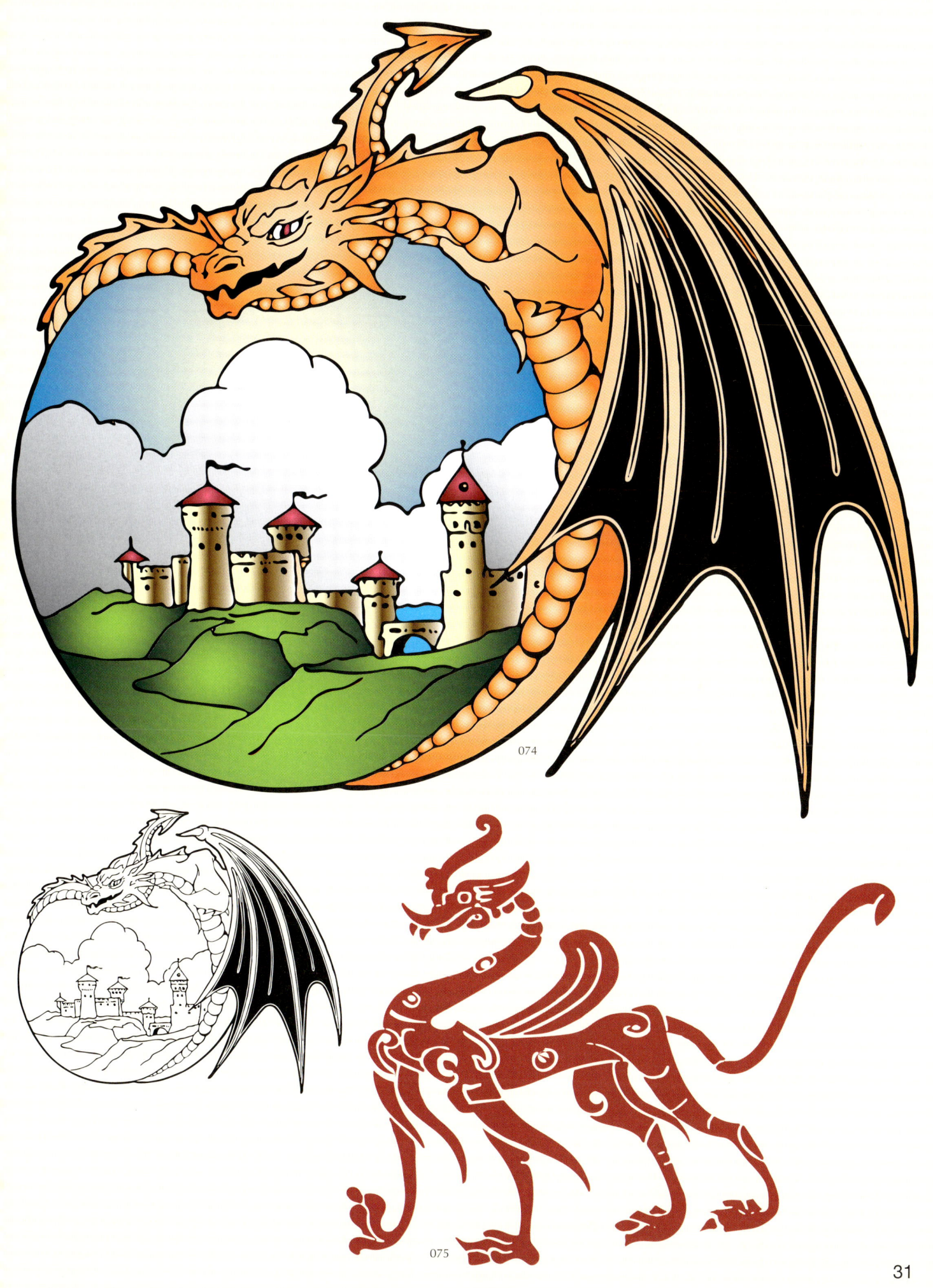

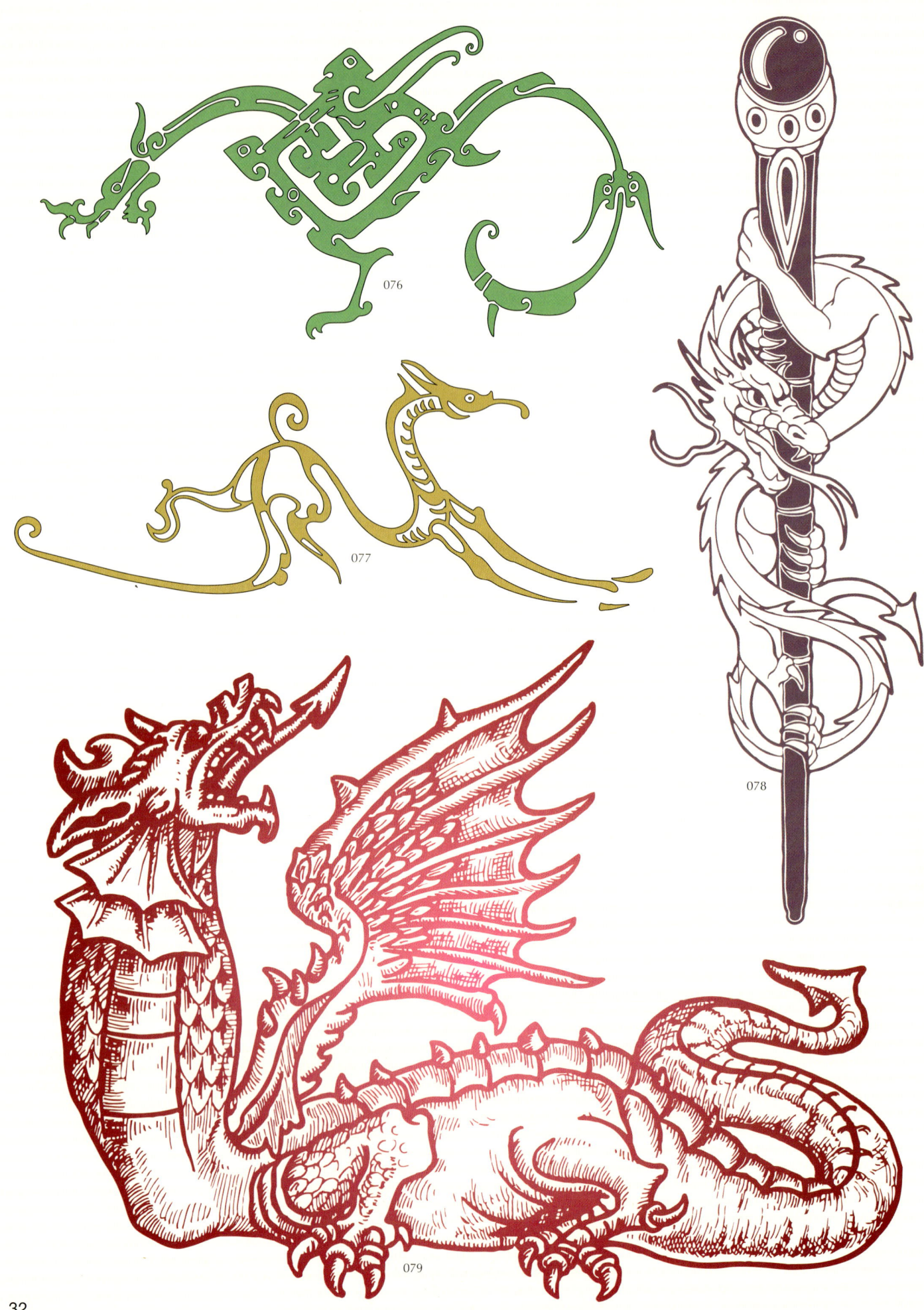

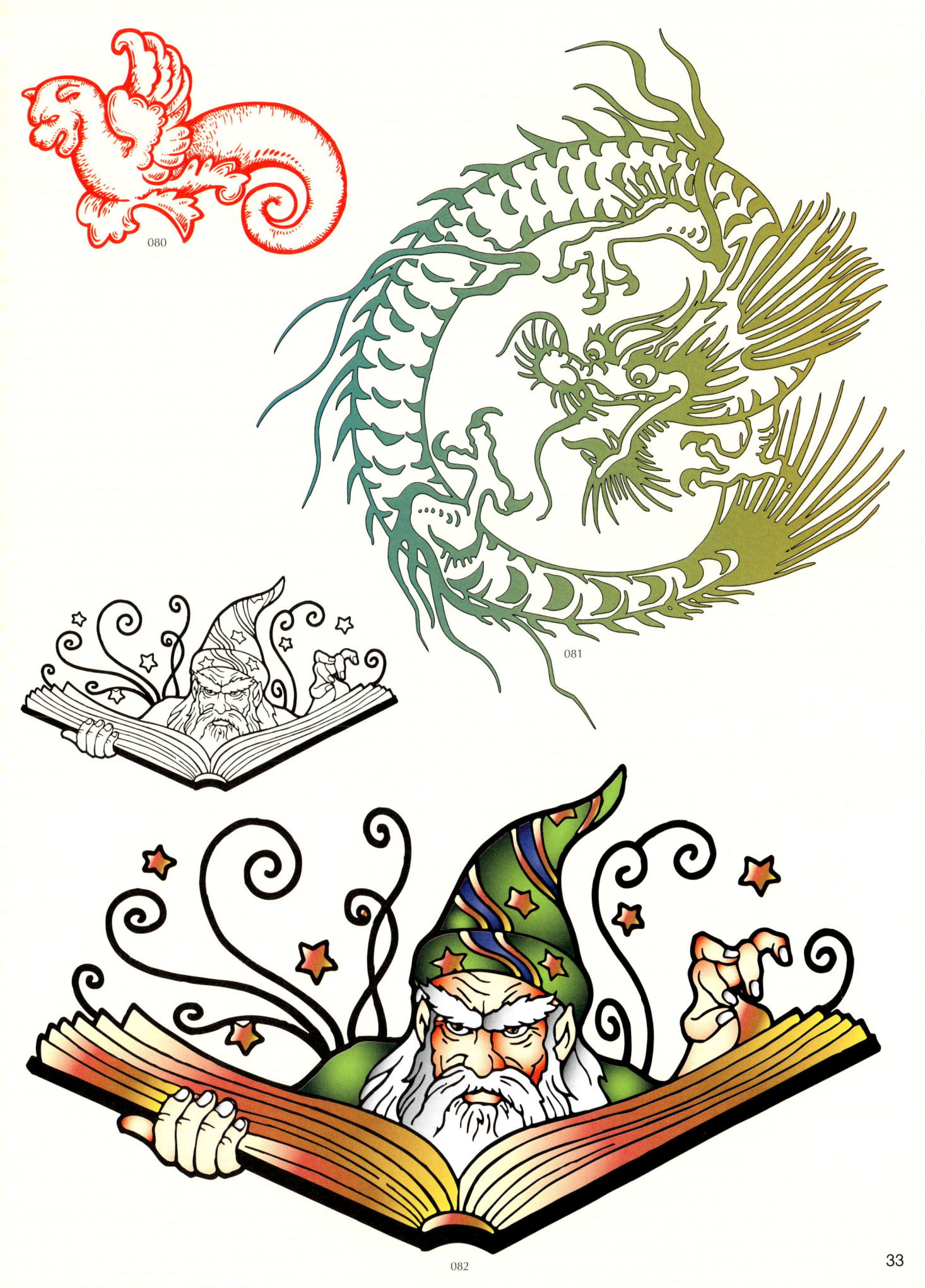

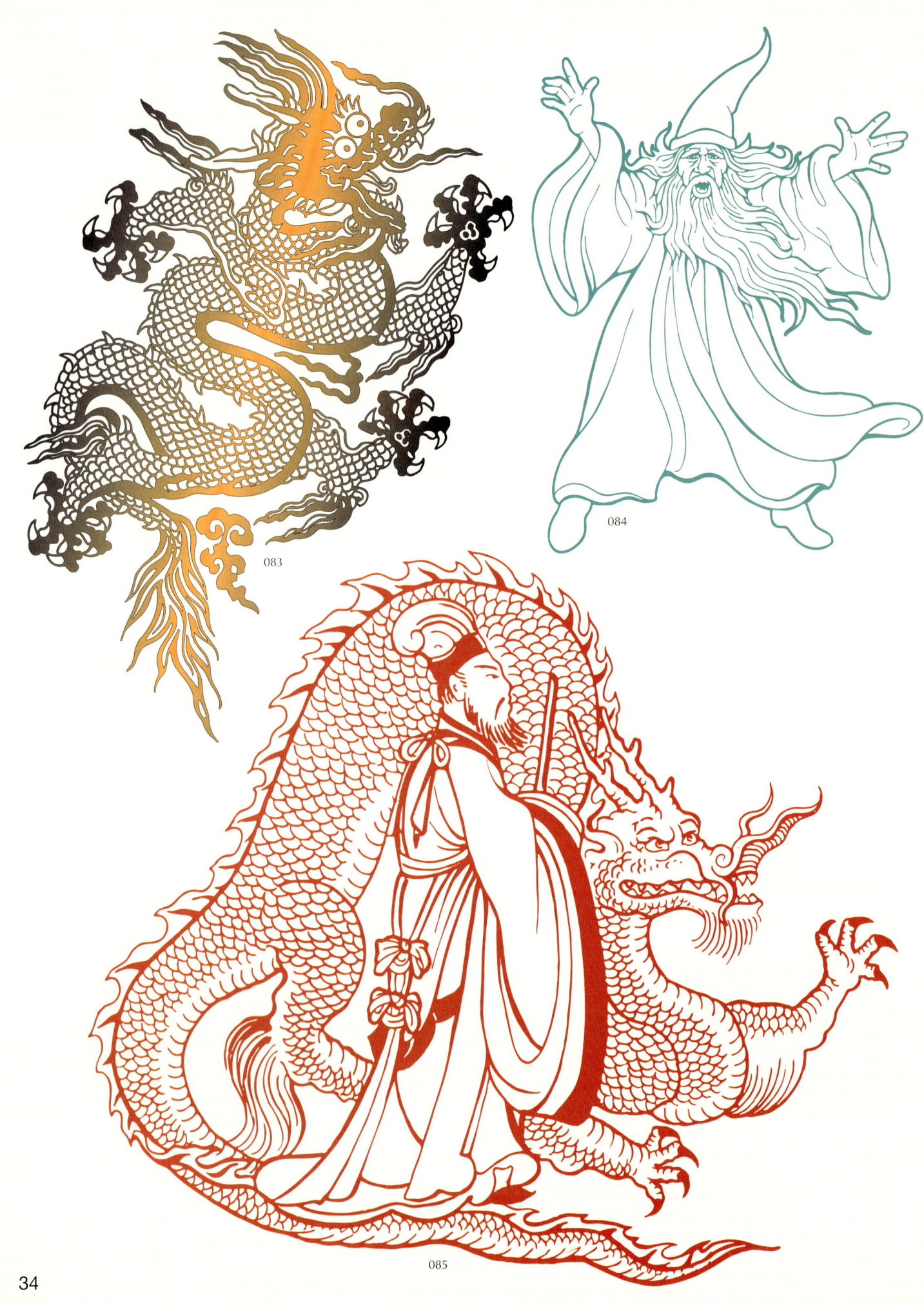

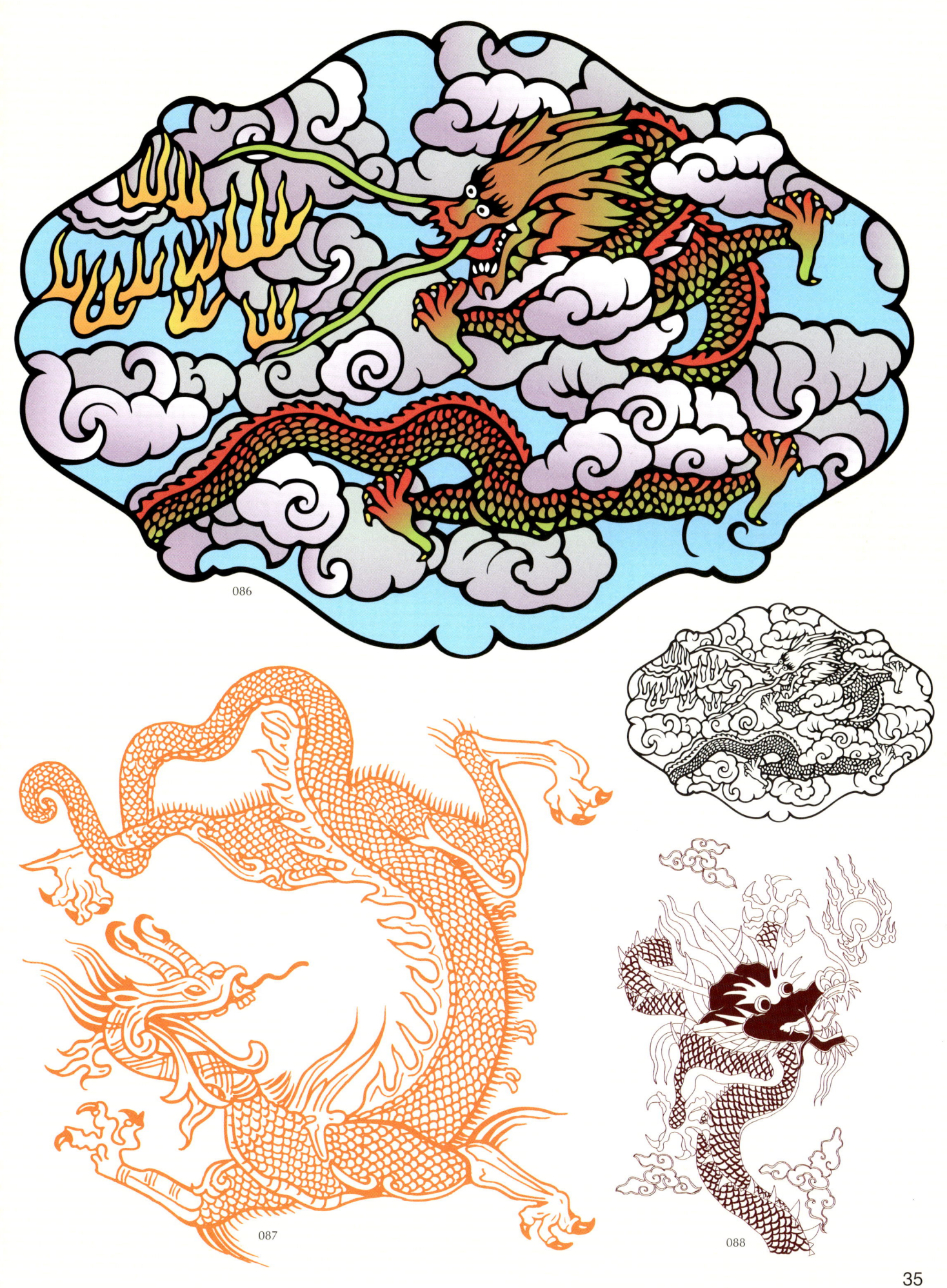

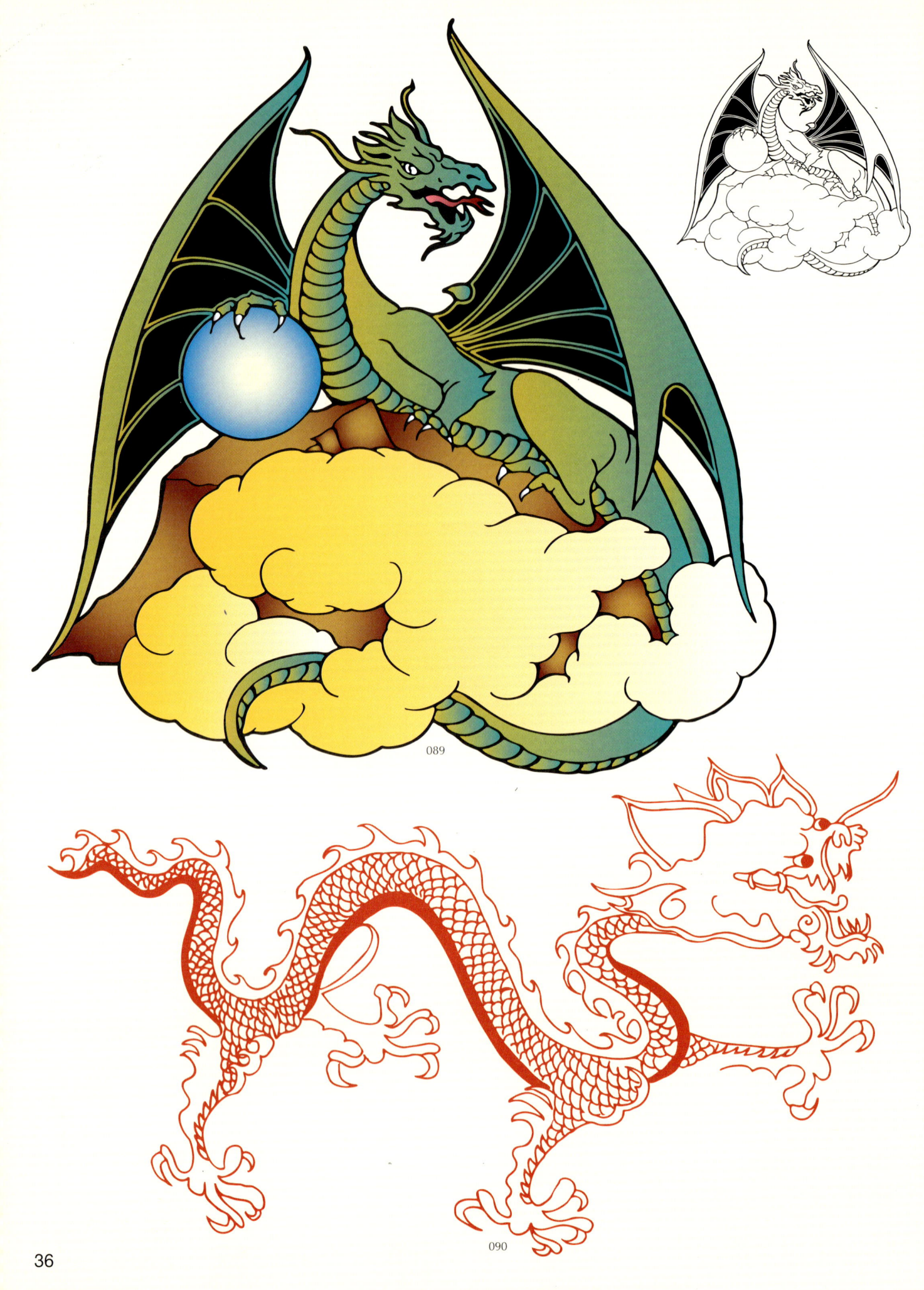

091

092

093

094

37

095

096

39

100

101

102

40

103

104

41

105

106

107

42

108

109

43

110

111

112

113

44

114

115

45

116

117

118

47

119